DATE DUE

JUL 5 '76

JUL 27 7

D1034624

THE TASTE OF OUR TIME

Collection planned and directed by

ALBERT SKIRA

84-88

BIOGRAPHICAL AND CRITICAL STUDY

BY

JEAN LEYMARIE

★

FIRST VOLUME

Translated by James Emmons

found the group in confident possession of a fully worked-out technique. Its mature style is seen at its best in the canvases painted at Argenteuil and Pontoise in the seventies, the happy period of perfect balance and cohesion. Manet's death in 1883 coincided with the breaking up of the impressionist group. Each artist thereafter went his own way, while at the same time a vigorous neo-impressionist generation stepped on to the scene; to the latter an important chapter is devoted. Impressionism, while sowing the seeds of its own destruction, broke the ground for all modern art, and there is no understanding Cézanne, Seurat, Van Gogh, even Matisse, without understanding the movement that set them free—a movement each of them completed even while repudiating it. Bonnard's art was the apotheosis of Impressionism. Gauguin, on the other hand, champion that he was of symbolism and abstraction, stood resolutely opposed to an art that relied so heavily on the data of the visual world. At last, in 1890, after a decade of vicissitude, the great masters of Impressionism reverted to the ideals of their youth, but greatly amplified now, cosmic and visionary.

The text is developed simultaneously from the historical, critical and aesthetic angles. Chosen and arranged with great care, the plates go hand in hand with the text. Together they give a lucid, coherent picture of the magnificent variety of expression and the steadfast spiritual unity that characterized Impressionism—that unexampled concourse of great painters, whose work, even while pointing to the future, held up both a poetic and a truthful mirror to life as it was lived in their time.

THIS two-volume study of Impressionism inaugurates a series of such studies, devoted to the leading movements of modern painting, which in due course will appear alongside the monographs on individual painters published under the general heading of "The Taste of Our Time."

The complexity of the impressionist movement and the wealth of available material are such that two volumes were necessary to cover it adequately. The first tells the story of Impressionism up to the pivot year of 1872: the rise of open-air painting and the swing-over from a dramatic realism that played on the emotions to a naturalism, or rather a natural way of seeing the world, devoid of moral or sentimental implications, essentially objective, essentially poetic. Once we see these two trends in their proper perspective, we see how the new generation of Manet and the Impressionists stood with respect to Courbet and the Barbizon School. The uphill struggle against embattled Academicism hinged on the choice of subject-matter, and this proved to be the test for 19th-century painters. All independent-minded artists embraced the "modern aesthetic" of Baudelaire, who urged them to open their eyes to the contemporary scene, to paint the life being lived around them in city and country. This was the rallying cry to which Impressionism answered, and as we follow the rise of the movement we also follow the whole artistic and literary life of its time, the manners and morals of the period, urban development and scientific progress.

The relevant documentary material will be found at the end of the second volume. This opens with the year 1873, which

v. 1, c. 3

3 1143 00151 3580
759.054 Ley
Leymarie, Jean.
Impressionism :
biographical and critical
study

Title Page: Pissarro, Upper Norwood Road with a
Carriage (detail), 1871. Neue Staatsgalerie, Munich.

<div align="center">★</div>

© by Editions d'Art Albert Skira, 1959.

All reproduction rights reserved by S.P.A.D.E.M.,
Syndicat de la Propriété Artistique, Paris, and Asso-
ciation pour la Défense des Arts plastiques et graphiques
(A.D.A.P.G.), Paris.

Library of Congress Catalog Card Number: 55-7701.

<div align="center">★</div>

Distributed in the United States by
THE WORLD PUBLISHING COMPANY
2231 West 110th Street, Cleveland 2, Ohio

Impressionism

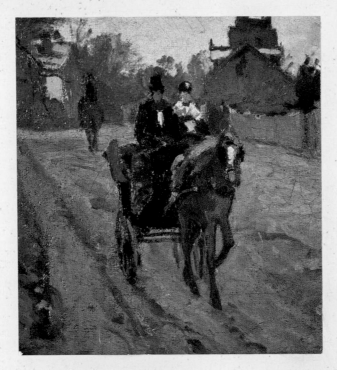

RICHMOND
PUBLIC
LIBRARY
CALIFORNIA

SKIRA

IMPRESSIONISM
BEFORE 1873

CHRONOLOGICAL SURVEY

1830 Birth of Camille Pissarro at Saint-Thomas in the West Indies.

1832 Birth of Edouard Manet in Paris.

1834 Birth of Edgar Degas in Paris.

1839 Birth of Paul Cézanne at Aix-en-Provence and Alfred Sisley in Paris, the latter of English parents.

1840 Birth of Claude Monet in Paris; his childhood and youth are spent at Le Havre.

1841 Birth of Auguste Renoir at Limoges, Frédéric Bazille at Montpellier, Berthe Morisot at Bourges, Armand Guillaumin in Paris. Renoir's family moves to Paris in 1845.

1848 Birth of Gauguin.

1853 Birth of Van Gogh.

1855 Pissarro and Whistler arrive in Paris.
Degas and Manet are students at the Ecole des Beaux-Arts. Renoir enters on his apprenticeship as a porcelain painter in a Parisian china factory.

1855 Paris World's Fair, with large-scale exhibitions of works by Ingres, Delacroix, Théodore Rousseau and Courbet.

1856 Degas travels in Italy, staying at Rome, Naples and Florence. Manet leaves Couture's studio after traveling in Holland, Austria, Germany and Italy, where he studies the masterpieces.

1856 Duranty runs a magazine: "Le Réalisme."
Courbet paints "Girls on the Banks of the Seine."

1857 Baudelaire publishes "Les Fleurs du Mal."

1858 Monet meets Boudin at Le Havre. The latter takes him along on painting excursions in the open country, where they work directly from nature. "A veil was torn from my eyes," Monet later wrote, "and in a flash I saw what painting meant."

1859 Monet comes to Paris, frequents the Brasserie des Martyrs, meets Pissarro at the Académie Suisse.

1859 Manet is rejected at the Salon, despite Delacroix's backing.

1859 Boudin, Baudelaire and Courbet stay at the Ferme Saint-Siméon, near Honfleur. Baudelaire praises Boudin's elliptical jottings from nature in his review of the Salon. Birth of Georges Seurat. Publication of Darwin's "Origin of Species."

1860 Courbet opens a studio of his own at the request of the Beaux-Arts students, among them Fantin-Latour, and chooses an ox as the first model.
Monet sent to Algeria on military service.

1860 Large-scale Exhibition of Modern Painting in Paris (Delacroix, Corot, Courbet, Millet).

1861 Manet's first appearance at the Salon, where he attracts attention. He becomes friendly with Baudelaire and Duranty, and exhibits at the Galerie Martinet.
Pissarro meets Cézanne and Guillaumin at the Académie Suisse.
Berthe Morisot studies under Corot at Ville-d'Avray.

1862 Meeting of Manet and Degas. The latter does his first pictures of jockeys and the races, while Manet paints his "Concert at the Tuileries."
Discharged from the army, Monet returns to Le Havre and paints with Boudin and Jongkind during the summer. Goes to Paris in November and enrolls in Gleyre's studio, formerly that of Paul Delaroche. There, amongst the newcomers, he meets Sisley, Renoir and Bazille.

1863 Manet, Pissarro, Jongkind, Guillaumin, Whistler and Cézanne exhibit at the so-called "Salon des Refusés," organized for painters whose work is rejected at the official Salon. Uproar over the "Déjeuner sur l'herbe"; from now on Manet is looked upon as the "ringleader" of the independent painters in their struggle for recognition.
Monet shares a flat with Bazille in the Place de Furstenberg, overlooking the studio of Delacroix, whom they often watch at work. They spend their Easter holidays working at Chailly, near Barbizon, on the edge of the Forest of Fontainebleau. Painting at Pontoise, Berthe Morisot meets Daubigny and Daumier.
Jongkind spends much of the year painting at Honfleur.
Tentative reforms made at the Ecole des Beaux-Arts.

1863 Essay by Baudelaire on Constantin Guys and "modernity" in painting. Death of Delacroix.

1864 Gleyre's studio having shut down, Monet takes his friends to the Forest of Fontainebleau, where they paint directly from nature. There Renoir meets Diaz, who gives him friendly tips and even helps him to sell his pictures. In the autumn Monet rejoins Boudin and Jongkind at Honfleur. "There's much to be learnt in such company," he writes to Bazille.
Manet paints the sea-fight between two American men-of-war, the Kearsarge and the Alabama, off the Cherbourg coast, paints "The Races at Longchamp" and takes a studio at 34, Boulevard des Batignolles.
Pissarro exhibits at the Salon as "Corot's pupil."

1864 Birth of Toulouse-Lautrec.

1865 Monet successfully shows his Honfleur seascapes at the Salon. He paints a large "Déjeuner sur l'herbe" in Fontainebleau Forest and seascapes at Trouville with Courbet, Whistler, Daubigny and Boudin.
Manet exhibits "Olympia" and travels to Spain in August, where he meets the critic Théodore Duret.
Renoir and Sisley paint together in Fontainebleau Forest.
Degas meets Zola and Duranty and paints his last historical picture, "The Evils befalling the City of Orléans." Turning towards the portrait and scenes of contemporary life, he undergoes the influence of photography and Japanese prints.

1865 Death of Proudhon, whose "Du Principe de l'art et de sa destination sociale" is posthumously published. Zola visits Courbet.

1866 Monet exhibits "Camille" at the Salon, paints views of Paris and works at Sainte-Adresse and Le Havre. Meets Manet, whose influence affects him conjointly with that of Courbet.
Renoir paints his "Inn of Mother Anthony" at Marlotte, in the Forest of Fontainebleau.
Courbet stays at Deauville with the Comte de Choiseul.
Corot and Daubigny are jury members at the Salon.
Pissarro's work is noticed at the Salon. He breaks away from Corot and paints on his own at Pontoise.
Rejected at the Salon, despite Daubigny's efforts in his behalf, Cézanne sends a letter of protest to the Director of Fine Arts but nothing comes of it.

1866 The Goncourt brothers publish "Manette Salomon." Zola writes enthusiastic articles on Manet and reviews the Salon in the newspaper "L'Evénement."

1867 Paris World's Fair. Manet and Courbet set up their own booths and show 50 and 110 canvases respectively.
Extreme severity of the Salon jury, all the Impressionists being rejected, except Degas and Berthe Morisot, with her "View of Paris from the Trocadéro."
Large figure compositions painted entirely in the open air: Monet's "Women in the Garden" and Bazille's "Family Reunion."
Renoir paints at Chantilly and Fontainebleau, Monet at Sainte-Adresse, Sisley at Honfleur, where Bazille does his portrait.
Cézanne moves back and forth between Paris and Provence, paints large, lowering, erotic compositions.

1867 Death of Baudelaire and Ingres. Birth of Bonnard. Karl Marx publishes "Das Kapital." Opening of the Suez Canal.

1868 Manet exhibits his "Portrait of Zola" at the Salon, then stays at Boulogne, whence he makes a brief trip to England. Fantin-Latour introduces him to Berthe Morisot, who poses for "The Balcony."
Monet works in Paris with Renoir and Bazille, then at Etretat and Fécamp, where he attempts to commit suicide.
Renoir successfully shows his "Lise" at the Salon.
Degas begins his methodical studies of dancers and stage scenes: "Mademoiselle Fiocre in the Ballet 'La Source'."

1868 Birth of Vuillard. Corot paints his "Woman with a Pearl." Zola praises Manet and Pissarro in his review of the Salon.
—

1869 Renoir and Monet work together at Bougival. With their versions of "La Grenouillère," the impressionist technique takes form.
Working on the Channel coast are Manet at Boulogne, Courbet at Etretat, Degas at Saint-Valéry-en-Caux.
Pissarro settles at Louveciennes, and first tries his hand at painting the gleam of light on water.
Gatherings of painters and writers at the Café Guerbois.

1869 Birth of Matisse. Death of Berlioz.

1870 Franco-Prussian War. Proclamation of the Third Republic.
Bazille killed in action at Beaune-la-Rolande, November 28.
Manet serves in the National Guard, Degas in an artillery unit, Renoir in a light cavalry regiment.
Cézanne retires to L'Estaque, finishes "The Black Clock."
Monet and Pissarro escape to England.

1870 Théodore Duret reviews the Salon.

1871 Having served as chairman of the Art Commission under the short-lived Commune, Courbet is accused of having dismantled the Colonne Vendôme and imprisoned at Sainte-Pélagie, where he paints some fine still lifes.

In London Monet runs into Daubigny, who introduces him to the dealer Durand-Ruel, to whom Pissarro is soon introduced in turn. Monet and Pissarro paint snow effects and views of the Thames and Hyde Park. Visiting the museums, they discover Turner and Constable.

Manet visits his family in the Pyrenees, then returns to Paris along the coast, painting seascapes all the way: "Bordeaux Harbor."

Renoir divides his time between Paris and Louveciennes, paints his "Portrait of the Henriot Family" and yields to Delacroix's influence.

Monet's first trip to Holland: "Views of Zaandam."

Pissarro returns to Louveciennes in June only to find his studio ransacked.

Degas stays with his friends the Valpinçons at Mesnil-Hubert.

1871 Duret sets out on a round-the-world trip by way of the United States and Japan. Birth of Rouault.

1872 Back in France, Monet visits Courbet in prison, accompanied by Houdin and Armand Gautier. After a second trip to Holland, he settles at Argenteuil.

Again in Paris, Durand-Ruel sounds out Degas and Sisley, then visits Manet's atelier and buys 30 pictures outright, for which he pays 51,000 francs. After this Manet takes a new studio at 4, Rue de Saint-Petersbourg, and in August travels to Holland to make a firsthand study of Frans Hals.

Pissarro leaves Louveciennes in April and moves back to Pontoise, where Vignon and Guillaumin join him. At the same time Cézanne settles down nearby, at Saint-Ouen-l'Aumône. Under Pissarro's influence his palette brightens up and he drops his luridly romantic themes for an objective study of landscape.

Degas takes to visiting the rehearsal rooms of the opera dancers. In October he sails for New Orleans with his brother René, only returning to Paris in April 1873.

Renoir paints views of Paris: "Le Quai Malaquais," "Le Pont-Neuf."

After a holiday at Saint-Jean-de-Luz, Berthe Morisot travels briefly in Spain, to Toledo and Madrid, where she admires Velazquez.

MANET AND THE GENERATION OF 1860

THE impressionist generation arose between 1830 and 1841: Pissarro was born in 1830, Manet in 1832, Degas in 1834, Cézanne and Sisley in 1839, Monet in 1840, Renoir, Bazille, Guillaumin and Berthe Morisot in 1841. Completely different in background, training, temperament and taste, but moved by the same keen spirit of independence and sincerity, these artists came together in Paris about 1860 and a stimulating comradeship sprang up between them at once. Two distinct groups took form, one at the Académie Suisse centered on Pissarro, the other at Gleyre's studio centered on Monet, while outside, in the Parisian art world, Manet rose to the fore. To him, in the years 1860-1870, fell the same revolutionary role Courbet had played from 1850 to 1860, though he broke even more drastically than his elder had with outworn conventions and ideas.

Pissarro came to Paris from the West Indies in 1855, just in time to witness the grand clash of principles between Ingres and Delacroix at the World's Fair exhibitions, as well as the large one-man show staged by Courbet at the Pavilion of Realism. Once he had seen Corot's work, however, he realized that this was the art for him. He enrolled at the Académie Suisse, where, for a small fee, artists could sketch freely from the living model, coming and going as they pleased. Courbet and Manet occasionally dropped in, and there in 1859 Pissarro met Claude Monet, who had just arrived from Le Havre with the well-wishings of Boudin. In 1861 came two new recruits: Armand Guillaumin and Zola's friend from Aix-en-Provence, Paul Cézanne. After eighteen months of military service in Algeria, where his eyes were opened to the meaning of light and color, Monet returned to Le Havre in the summer of 1862. He received a warm welcome from Boudin and Jongkind; by November he was back in Paris.

Gleyre's studio enjoyed a reputation for relatively liberal teaching methods, an added attraction being the very nominal fees and the picturesque atmosphere of the place. More than five hundred artists "went through the mill" there, among them Whistler. Monet lost no time in enrolling and fell in with several other newcomers: Bazille, Sisley and Renoir. It was during this winter that Gleyre scornfully put his famous question to the latter: "Do you paint merely to amuse yourself, young man?" To which Renoir, completely taken aback by this dig, replied with the utmost candor that it had never occurred to him to paint for any other reason—which voiced the spontaneity and freedom of expression of the whole group. They kept in touch with their friends at the Académie Suisse chiefly through Monet, and also Bazille, who had met Cézanne. In the spring of 1864, Gleyre's studio shut down for good, to the delight of Monet, who had had enough of even this mild form of discipline and now induced his friends to join him at Fontainebleau Forest, where they painted in the open air, directly from nature. At the same time Berthe Morisot, a pupil of Corot since 1861, was working at Pontoise with Daubigny. These young artists thus congregated on the eve of the first serious breach made in the ramparts of officialdom, in May 1863: the Salon des Refusés, which gave a hearing to the younger men in their struggle for recognition, and brought Manet into the limelight.

Born into a well-to-do Parisian family, a man of polished manners, refined tastes and genuine culture, Manet was very different from the eager young provincials who looked to him for leadership. Drawing on the living heritage of the museums as against the hidebound conventions of the schools, he pronounced the first unmistakable accents of modern art. In the darkest period of academic complacency, Manet made good against all odds, with the utmost grace and simplicity, imposing an entirely new notion of painting. "The eye, a hand," was how he summed

it up to Mallarmé, with no intermediary between the paints and the painter's emotion. In the fervid, experimental years before the war of 1870 the Impressionists-to-be still clung to the collective example of Boudin and Jongkind, of Corot, Daubigny and above all Courbet; from 1865 on, one after another, they came into direct contact with each of these men, their elders, whose combined influence affected them steadily and salutarily, its emphasis naturally shifting according as they worked in Paris, at Fontainebleau or on the Channel coast. As regards technique, however, it took Manet to set them completely free, to give body to the broad principle that both bound them fraternally and left each to his own inspiration: themes taken from the contemporary scene, in city and country, treated in a style free and natural, spontaneous, frank and sincere.

At the World's Fair held in Paris in 1867, his private booth stood next to Courbet's on the Pont de l'Alma. The pictures he showed there provoked jeers and laughter from the crowds, but the younger men admired and studied them. His art bridged the gulf between two generations, two eras of taste. Without raising his voice, delivering none of the noisy broadsides Courbet was wont to burst out with, Manet modestly explained that "the effect of sincerity is to turn these works into a kind of challenge, whereas the painter only intended to render his impression, sought simply to be himself and no one else." What better definition exists of the genuinely original artist? This was the ideal that produced the miracle of Impressionism.

Two group-portraits by Fantin-Latour illustrate the historical significance of the role Manet played: the *Homage to Delacroix* (1864), in which he stands with Baudelaire in the foreground beside a portrait of the master they revered, who had died the year before, and the *Studio at Batignolles* (1870), Manet's own studio in which we see him seated at his easel, gravely flanked by Astruc, Zola, Bazille, Renoir and Monet.

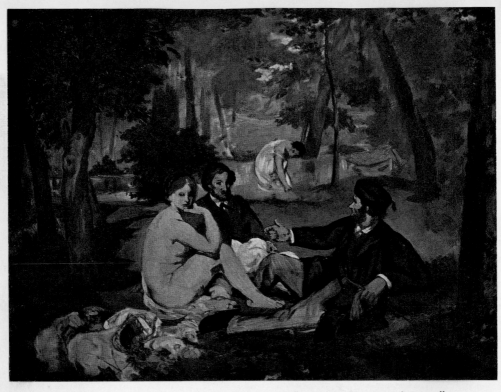

ÉDOUARD MANET (1832-1883). SKETCH FOR "LE DÉJEUNER SUR L'HERBE,"
1862-1863. (35 ¼ × 45 ½")
COURTAULD FUND, TATE GALLERY, LONDON.

This is a preliminary sketch for the famous picture in the Louvre, which created an uproar at the Salon des Refusés in 1863, the Emperor himself declaring it "indecent." Yet it is only a restatement of a classical theme popular with the Venetians. What shocked was its modern, daringly life-like presentation, without any mythological "justification." "What we should note," wrote Zola, "is the landscape as a whole, with its vigor and finesse, its broad, solid foreground and the dainty, delicate depths beyond."

1863

The year *1863* is a landmark in painting. That year, as he reviewed the Salon and attempted to assess what he described as "the real trends art is taking in my time," Castagnary observed the transition from a dramatic realism *that played on the emotions to a* naturalism *devoid of either social or sentimental implications, objective and poetic at once. This was enough to assign their historical position to Manet and the Impressionists-to-be with respect to Courbet.*

After his one-man show in March and April at the Galerie Martinet, where Lola de Valence *and* Concert at the Tuileries *attracted much attention, Manet overshadowed everyone else at the famous Salon des Refusés in May, which also included Pissarro, Jongkind, Whistler, Guillaumin and Cézanne. The same crowd that, at the official Salon, went into ecstasies over Cabanel's* Venus, *a sleek nude bought by the Emperor himself, greeted the* Déjeuner sur l'herbe *with sneers and indignation, for while its limpid colors might have been acceptable, its forthright modernity of vision certainly was not. Choice of subject-matter proved to be the test for 19th-century painters, and this it was that hastened the inevitable break between "respectable" philistine tastes and the modern era of pure painting that lay ahead. All independent-minded spirits henceforth looked to Manet as their champion in the coming struggle against the academicians in power.*

On August 13 Delacroix died. Though he carried away with him the fever calm and the arrested tumult of a spiritual realm all his own, he left behind not only a precious example of individualism and creative freedom, but also what Cézanne, one of his greatest admirers, was to call "France's finest palette." For in his palette lay all his vibrancy, his musicianship, and the technical finds he intuitively made in the field of color, which determined the future course of modern painting. His impact on Impressionism and its aftermath, from Monet to Seurat, was studied in detail as early as 1899 by Paul Signac in a remarkable essay, D'Eugène Delacroix au Néo-Impressionnisme.

THE CHANNEL BEACHES

B EFORE settling down on the banks of the Seine and the Oise, where their true style took form, Monet and his friends roamed from the Ile-de-France to the sea and back again, from Fontainebleau Forest, which they still painted in the dense and sluggish manner of their elders, to the beaches of the Channel coast, where their palettes quickly brightened up. An old haunt of the English watercolorists, notably Bonington, and of such romantics as Delacroix, Huet, Flers, Isabey and Dupré, visited by Corot, then forgotten in the palmy days of Barbizon, the Seine estuary and the Normandy coast became a flourishing center of open-air painting between 1858 and 1870.

Here Impressionism was born, thanks largely to Eugène Boudin, a native of the region, who spent most of his life painting along the Channel coast. He was Monet's mentor and played host to Courbet, Baudelaire, Jongkind and many younger men, whose eyes he opened to the color-magic of light and water. Though he had grown up at Le Havre, was familiar with the sea, felt at home along the beaches and docks, Monet was still dabbling in caricature when in 1858 he had the good fortune to meet Boudin, who recognized his gifts at once and took the youth with him on his outings into the open country, where they painted together directly from nature. "It was as if a veil had been torn from my eyes," Monet later recalled, "and in a flash I saw what painting really meant."

The following year, in May 1859, acting on the advice of Boudin, Monet went to Paris. He admired Corot and Daubigny, but noticed that not a single seascape was to be seen at the Salon. In June Courbet paid a visit to Le Havre. There he was struck by some seascapes he saw in a shop-window and promptly hunted out the man who had painted them. It was Boudin, who took Courbet with him out to La Mère Toutain's famous inn

at the Ferme Saint-Siméon, near Honfleur, a popular place with local fishermen and artists, with a splendid view over the Seine estuary. Out walking together one day, they ran into Baudelaire, who had come to Le Havre to see his mother. He, too, was greatly struck by Boudin's "direct jottings" of sky and sea as they changed according to "the season, the time of day and the wind." He lauded these "meteorological beauties" in his review of the 1859 Salon, drawing a sharp distinction between the sketch and the picture, but admiring Boudin's ability to turn out finished works that retained all the freshness and vivacity of the sketch. The achievement of Impressionism was precisely this harmonious union of long-accepted opposites, this power of improvising freely on the canvas.

JOHANN BARTHOLD JONGKIND (1819-1891). BEACH AT SAINTE-ADRESSE, 1863. (11¾×22¼″) WATERCOLOR. LOUVRE, PARIS.

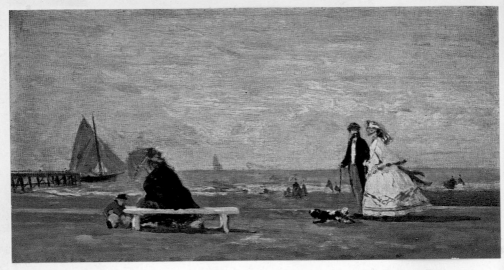

EUGÈNE BOUDIN (1824-1898). BEACH AT TROUVILLE, 1863. (7×13¾″)
THE PHILLIPS COLLECTION, WASHINGTON.

In 1861, while Monet was doing military service in Africa, Boudin worked in Paris, where Corot saluted him as the "monarch of the skies." The sky is in fact the distinctive feature of a landscape. Constable regarded it as a mirror of his feelings, while only by virtue of Holland's vast, fitful skies did 17th-century Dutch painting come into its own, advancing from the Flemish mannerism of Momper to the native lyricism of Jan van Goyen. A similar evolution—from the romanticism of Barbizon to the pre-Impressionism of Honfleur—now occurred in Normandy, where the sky, an endless procession of wind-driven clouds scudding across it, looked down on the ocean as into a boundless mirror. In 1862 Boudin settled at the Ferme Saint-Siméon, where thanks to him a "School of Saint-Siméon" arose, as the Barbizon School had arisen a decade earlier.

In his autobiography, published in *L'Art* in 1887, Boudin gave a very accurate, though over-modest account of the role he had played. After touching on his own work, notably his seascapes, he wrote: "All this is too little deserving of note to rank me beside today's outstanding talents. But though I cannot claim to stand among them, I may well have had some small measure of influence in the movement that led painters to study actual daylight and express the changing aspects of the sky with the utmost sincerity. If some of those whom it was given to me to encourage in this direction, Claude Monet for example, have been carried much farther than I by their own temperament, they may still be said to owe me a small debt of gratitude, just as I owed those who gave me advice and offered me models to follow." Monet, as a matter of fact, never made a secret of his lifelong gratitude and affection for Boudin.

Discharged from the army in the spring of 1862, Monet hurried back to Le Havre. That same year, saved in the nick of time from the utter moral decay with which drinking bouts and Bohemian ways threatened him, the Dutch painter Jongkind returned to the region of the Lower Seine, already familiar to him from a long stay made there with Isabey from 1847 to 1852, and began producing those bold, vibrant, wonderfully luminous watercolors that were the most perfect of their kind until Cézanne came on the scene. Monet now made his acquaintance, introduced him to Boudin, and the three men worked together daily. Feeling fit again and exulting in his powers, Jongkind spent the greater part of 1863 working at Honfleur, returning again in 1864 and 1865.

As early as 1863, Castagnary observed that Jongkind's greatness lay in the *impression* he rendered. Though his studio-made pictures, ponderous, heavily compounded works, remained within the realist and romantic traditions, his watercolors were sketched with a light, free, rapid touch, straight from the life.

With this seascape, patterned on a canvas by Jongkind painted at the same time from the same spot, Monet first tried his luck at the official Salon in 1865. His picture was not only accepted, but attracted much attention, for which Manet, however, got all the credit, their names then being frequently confused. Reviewing the Salon in the *Gazette des Beaux-Arts*, Paul Mantz extolled "the harmonious interplay of similar tones... his bold manner of seeing things and getting his vision across to the spectator." However traditional the composition remains, however subdued and narrow in range the color-scheme amid the dominant shades of grey, Monet's "bold manner" amply justifies its name in the broad, elliptical treatment of the scene, the vast sense of space, the fitful cloud banks billowing into the sky, the intensity of the brushwork on houses and clouds, the dabs of color in the boat that relieve the grey of the sea.

CLAUDE MONET (1840-1926). THE BREAKWATER AT HONFLEUR, 1864. (21¼×31¾″) JÖHR COLLECTION, ZURICH.

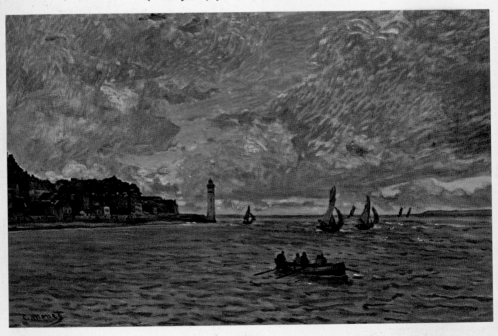

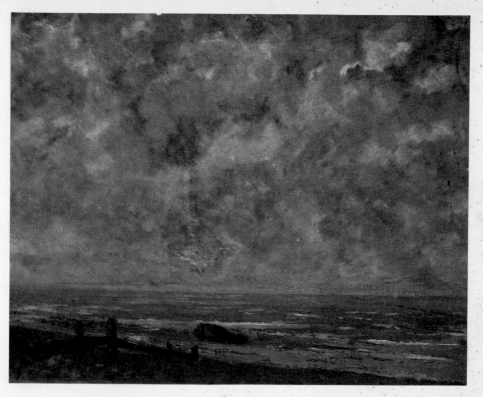

GUSTAVE COURBET (1819-1877). CALM SEA, 1869. (15 × 17½")
MUSÉE DES BEAUX-ARTS, CAEN.

Taken up by the Duchesse de Morny, Courbet met with considerable success in high-society circles at Deauville and Trouville in 1865, and fashionable women flocked to his studio. Yet he somehow found time to paint more than twenty seascapes in the course of that year, followed by many others in the four years to come, during annual visits to the Channel coast. Unlike Monet, he made no attempt to analyze light effects, but aimed at conveying the majestic expanse of the sea, dotted here and there with brighter accents. All his prowess as a tonal painter went into this canvas.

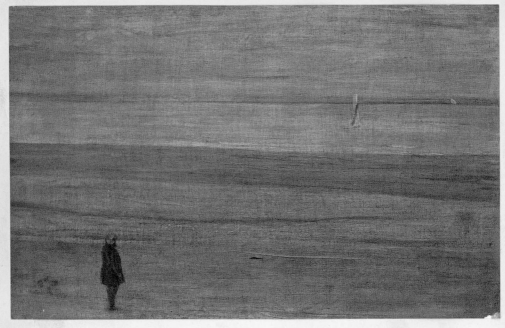

JAMES WHISTLER (1834-1903). COURBET AT TROUVILLE, 1865.
(19½×29¾″) ISABELLA STEWART GARDNER MUSEUM, BOSTON.

Nothing came more unexpectedly than the friendship that, for a time at least, linked so robust, earthy and egotistic a man as Courbet with young Whistler, a city man and a dandy, even more egotistic. Yet the latter openly declared himself Courbet's "pupil" and accompanied the master in 1865 to Trouville, where Monet, Boudin and Daubigny were also staying. Showing Courbet alone on the beach, as he gazes over the immensity of the sea, broken by a single sail, this canvas is not only a unique document, but one of the few works in which Whistler's highly refined colors suit a natural, everyday scene. Sand, sea and sky form a "harmony in blue and silver" whose effect verges on the musical. Whistler was too much of an intellectual, however, to embrace Impressionism. By 1866 he had already repudiated the naturalism of Courbet and begun to cultivate the decorative arabesques whose grace and virtuosity are inseparable from their artifice.

26

Those he made at Honfleur from 1863 to 1865 are perhaps his finest, incomparably fresh and limpid. In his *Journal* on May 4, 1871, Edmond de Goncourt entered the following comment: "What strikes me is Jongkind's influence. All landscapes of any value today stem from this painter, borrow his skies, his atmosphere, his sites. Nothing is more obvious, yet no one mentions the fact." Monet, however, freely declared his debt to Jongkind, while Boudin had this to say: "I, too, came in by the door he had forced and timidly embarked on my seascapes."

In July 1864 Bazille worked awhile with Monet on the Channel coast, then returned to his parents' home at Montpellier. From the Ferme Saint-Siméon, where he remained well into the autumn, Monet wrote to him: "There are a good many of us on hand now... Boudin and Jongkind are here, and we get on splendidly together. I regret your not being with us, for there's much to be learnt in such company." He turned these lessons to good account, needless to say, yet their tonic effect on him must not be exaggerated. Though patterned on a contemporary canvas by Jongkind, Monet's *Breakwater at Honfleur* already says much for the acuity of his own powers of vision and analysis, while also showing a conscious striving to revitalize his technique and deepen his sensibility—something which, for all their mastery, neither Boudin nor Jongkind had ever bothered about, the one too much of an artisan, the other essentially self-taught and instinctive.

Ocean bathing was fast becoming a favorite pastime now that the railway had put the Normandy beaches within easy reach of Paris. The Duke of Morny launched Deauville and Trouville, the two most fashionable resorts, while in *Manette Salomon* (1866) the Goncourt brothers recommended Trouville as an ideal spot for painters. Courbet could be seen there in 1865, strolling along the ocean front like a man of the world; in his train came his "pupil," the American painter Whistler, while

Daubigny, Boudin and Monet were also on hand and yielded to his influence. Courbet exulted in sea and sky, his palette brightened up and his colors grew rich and intense, though he never discarded his priming coat of brown and his practice of tonal painting, whereas Monet tackled the white surface of the canvas without further ado and was already dabbing on pure colors. Each summer, from 1866 to 1869, Courbet returned to the Channel beaches. Whether stormy or calm, always freely, powerfully constructed, perhaps the choicest things in his output, Courbet's seascapes are the finest of the 19th century after those of Delacroix.

Monet, too, loved the sea and from 1866 to 1870 returned each year to the Channel coast, either to Sainte-Adresse where his family lived, or to nearby Le Havre, Fécamp, Trouville, Etretat. And though reduced to so dire a state of poverty that he actually made an attempt at suicide, he continued to produce pictures whose number, boldness and luminosity quite belied the trials of his everyday life. Berthe Morisot painted at Lorient in 1869; Manet worked at Boulogne in 1868 and 1869, producing freely, broadly handled seascapes that vouch for his growing interest in light-effects and open-air painting, while Sisley, too, though no seascape-painter, stayed awhile at Honfleur in 1867, where Bazille made a portrait of him. Even Degas, whose scathing irony never flowed more readily than when leveled at landscape-painters, spent much of the summer of 1869 at Boulogne, Trouville and Saint-Valéry-en-Caux; the dainty pastel seascapes he brought back with him to Paris remained hidden away in his studio until his death. Only Renoir, wrapped up in Parisian life, and Pissarro, a man of the soil, showed no interest in the Channel coast and the sea.

Among 20th-century painters, Friesz, Dufy and Braque all grew up at Le Havre, while Marquet and Bonnard found there the iridescent stuff of their own neo-impressionist vision.

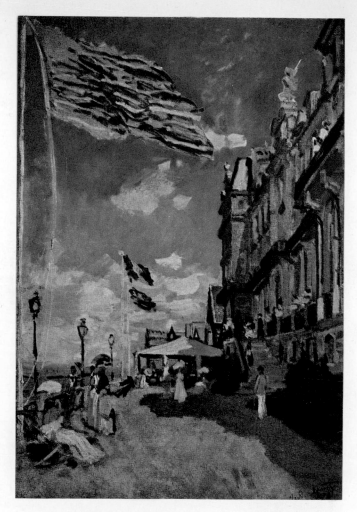

CLAUDE MONET (1840-1926). HOTEL DES ROCHES NOIRES,
TROUVILLE, 1870. (31½×22″) J. LAROCHE COLLECTION, PARIS.

PARIS AND THE CONTEMPORARY SCENE

IN his review of the 1859 Salon, so rich in foresight and prophecy, Baudelaire complained that there were no sea-scapes to be seen; we have just noted how abundant they proved to be in the following decade. He also deplored the absence of what he called "the big-city landscape," and this, too, from the very outset, was one of the Impressionists' most characteristic themes. The "big city" was the key notion of Baudelaire's aesthetic, the aesthetic on which all 19th-century art hinged, which we of today have inherited, and which may be summed up in the word "modernity". This notion he first brought forward in his 1845 Salon—"the *painter*, the true painter to come, will be he who wrests from the contemporary scene its epic side and shows us, through color and line, how great and poetic we are in our ties and polished boots"—and it forms an important chapter in his 1846 Salon, entitled *On the Heroism of Modern Life*, in which we find these often-quoted words: "Parisian life is rich in marvelously poetic subject-matter. Like the surrounding atmosphere, the marvelous envelops and sustains us, but we fail to see it." The idea is reverted to and skillfully developed in his famous study of Constantin Guys, which came out in the all-important year of 1863. "By modernity," wrote Baudelaire, "I mean the transitory, the fleeting, the incidental, one half of art, whose other half is the eternal and immutable. Modernity existed for each of the Old Masters, and most of the great portraits that have come down to us from former times are clothed in the fashion of the period. Their harmony is flaw-less because the costume and headdress, even the movements, gaze and smile (for each period has its demeanor, its gaze, its smile) go to form a whole whose vitality is unimpaired. You have no right," he adds, addressing himself to artists, "to scorn or bypass this transitory, fleeting element whose changes are so

frequent... for almost all our originality wants the stamp time leaves on our sensations." Here, in a few words, are the program and the ideal the Impressionists set themselves.

So acute an awareness of the contemporary scene, which seems natural and necessary to us today, was a revolutionary novelty in the mid-19th century, especially where art was concerned, for here conventions were most firmly entrenched. This awareness sprang from a keen feeling for the past and from the rapidly increasing signs of material prosperity that came with urban and industrial progress. The population of Paris doubled under the Second Empire (1852-1870) and, entirely recast and embellished by Haussmann, the city was split up into bourgeois and proletarian quarters that remain distinct to this day. Despite the poverty and smoldering discontent of the working classes, Paris shone far and wide as the brilliant capital both of luxurious living and the things of the spirit. Revolutions and class warfare dramatically put the seal on her rise to the forefront. The symbol found expression in Delacroix's *Liberty guiding the People* and the humanitarian ideals of 1848 implicitly inspired much of the work of such men as Victor Hugo, Balzac and Daumier. Courbet shared this faith and several times went on record, notably in the *Courrier du Dimanche* in 1861, as exhorting artists to be at one with their own time and express it to the full. "No period can possibly be reproduced except by its own artists," he wrote, "by which I mean the artists who have actually lived through that period. I hold the artists of one century as downright incapable of reproducing the climate of either a past or a future century... Historical painting, by its very essence, is contemporary." Courbet nonetheless confined his own world to the soil of his native province, and the epic forms he gave it evoked not contemporary, but eternal man, not the motion of the seasons, but the grandeur of the elements. With the young painters who came to the fore in the sixties, all moral

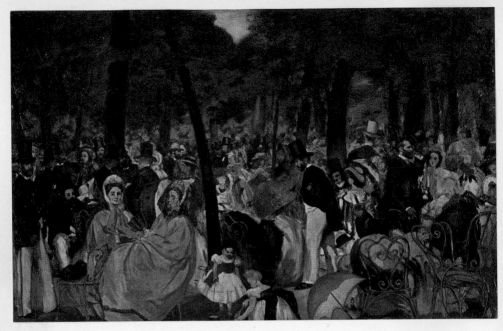

ÉDOUARD MANET (1832-1883). CONCERT AT THE TUILERIES, 1862.
(30×46¾") BY COURTESY OF THE TRUSTEES, NATIONAL GALLERY, LONDON.

We could hardly ask for a more authentic picture of contemporary life than this bold canvas, a masterly patchwork of vivid jottings, firsthand, spirited, precise in every detail, showing elegant company gathered for an afternoon concert in the Tuileries gardens. Among the strollers in black frock-coats, cream-colored trousers and top hats, we can identify from left to right Count Albert de Balleroy, standing, sporting a monocle, Zacharie Astruc, seated, Eugène Manet, the artist's brother, Offenbach the composer; farther back are Baudelaire and Théophile Gautier; mingling with the crowd are Champfleury, Fantin-Latour, Baron Taylor, Aurélien Scholl. The two ladies on the left, whose beige cloaks form the radiant hub on which the whole color-scheme turns, are Madame Lejosne and Madame Loubens. Metal chairs, an open sunshade, beribboned girls with their pails and hoop—a wealth of exquisite detail fills the foreground.

and social tension went out of painting and they delightedly pictured the scenes of town and country life they saw around them. Paris to them was not the dramatic stage of contending passions and energies, or the front line of a life-and-death struggle between the classes; it was a continuously unfolding, infinitely varied spectacle hitherto unpainted, a marvelous interplay of forms and lights.

The new poetry of painting burst upon the art world in 1862 with Manet's *Concert at the Tuileries* (National Gallery, London), a large, sketch-like canvas, bright with color. The boldness of the work lay less in the choice of the theme, though this was daring enough for the time, than in the spirited, elliptical sweep of the brushwork, perfectly attuned to the modern way of seeing and immediate in its appeal.

ÉDOUARD MANET (1832-1883). RACES AT LONGCHAMP, 1864. (17×34¼″) ART INSTITUTE OF CHICAGO. (PHOTOGRAPHED BY RICHARD G. BRITTAIN)

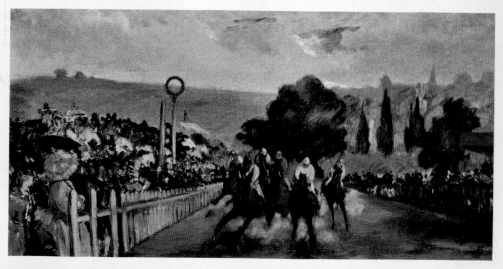

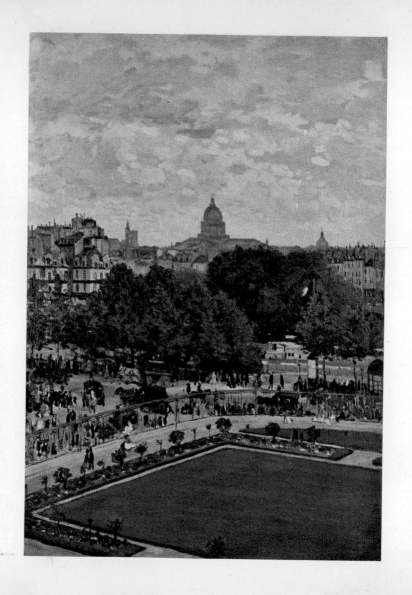

◀ CLAUDE MONET (1840-1926). LE JARDIN DE L'INFANTE, 1866. (35¾×24¼")
THE DUDLEY PETER ALLEN MEMORIAL ART MUSEUM, OBERLIN, OHIO.

These two canvases, painted in 1866 from the upper balconies of the Louvre, are contemporaneous with the first snapshots and aerial views of Paris. Below, the Quai du Louvre, with the Pont-Neuf spanning the Seine, houses dotted round the Place Dauphine and lining the Quai des Grands-Augustins, and in the distance the dome of the Panthéon towering over the Val-de-Grâce and the Collège Henri IV. On the opposite page, the same view but lower now, bringing the green lawns of the garden into focus.

CLAUDE MONET (1840-1926). QUAI DU LOUVRE, 1866. (24¼×36")
MUNICIPAL MUSEUM, THE HAGUE.

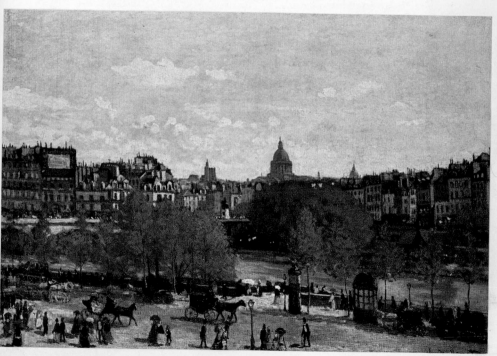

Manet straightaway bared the rich vein Baudelaire had been pointing to for years, and the art that after him came to be known as "modern painting" was in reality the only true and durable painting of the time, for its modernity was not merely a novel attribute, but the abiding substance of its vigor, appeal and autonomy. All his life Manet dreamt of producing a vast decorative mural on the theme of modern Paris, but the scheme was unfortunately never carried out.

For his part, after 1865, Degas had had his fill of the large historical pictures his sense of tradition had led him to paint. He, too, found the perfect outlet for his acute powers of analysis and observation in everyday life, as it was then being described by the naturalist writers. Trained in the great museums of France and Italy, just as his friend Manet had been, and like him a highly cultured, well-to-do Parisian gentleman, Degas aspired to a technique that should reconcile the inspirations of the intense life around him with the classical lesson of the Old Masters. "Ah, Giotto!" he ardently scribbled in a notebook in 1856, "leave me free to see Paris, and Paris! leave me free to see Giotto." It is generally conceded that he was painting the horseraces even before Manet took up this theme which had already been treated of course by the romantics and in particular by Géricault, but only for the sake of the horses and their beauties of form. Degas and Manet made much of the races as an elegant, colorful spectacle in the open air, though the dominant character of the races as a social function, so congenial to them, had a chilling effect on the other Impressionists, who came of modest families and felt more at home in popular gatherings. Each of these two men took a different approach to interpreting light and movement out of doors: Manet practised a fresh and sparkling array of color-patches arranged in dark and light zones, while Degas went in for ingenious lay-outs of highly expressive lines and planes. Except

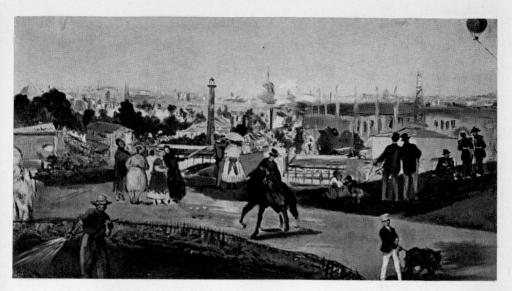

ÉDOUARD MANET (1832-1883). VIEW OF THE PARIS WORLD'S FAIR, 1867. (42½×77″) NATIONAL GALLERY, OSLO.

for these racing pictures and a few seascapes and beach scenes, Degas never showed the slightest interest in open-air painting. He felt that "the air we find in the Old Masters' pictures is not the air we breathe." As indifferent to the life of the streets as he was to the beauties of the open countryside, but a passionate observer of the secret workings of the human mind and body, he loved the city—as Lautrec did after him—for the intense life that went on behind the scenes, for the artificial lighting of closed rooms and theaters. His first study of a dancer dates to 1867 or 1868; this was *Mademoiselle Fiocre in the Ballet "La Source"* (Brooklyn Museum). His first picture of ballet dancers in the full glare of the footlights, in a boldly original lay-out, played off against the somber depths of the orchestra

pit dotted with the figures of the musicians and their instruments, was his *Musicians at the Paris Opera* (Louvre), which dates from about 1869.

Monet's technique had grown noticeably freer on the Channel beaches, where his pictures included not only the sea and the sky, but the colorful figures of fashionably dressed city folk on holiday. Then, by 1866, he had discovered that Paris, too, was a marvelous landscape, with the Seine and its bridges, with its parks and public monuments, the plays of light and perspective, the sweep and movement of hurrying crowds and carriages. From the balconies of the Louvre, along a plunging line of sight and from various angles, he painted the *Church of Saint-Germain-l'Auxerrois* (National Gallery, Berlin), the *Jardin de l'Infante* and the *Quai du Louvre*, bold canvases all, exhibited in the small shop-window of the dealer Latouche, where they excited the admiration of Diaz, irritated Daumier, astonished Manet and clearly foreshadowed his mature style. The silhouettes of strollers and passing hansoms are brushed in with all the dash and vivacity of Jongkind's sketches, while the light, dancing down through the leaves and shattered into a thousand brilliant, knife-sharp points, clashes with the local color of lawns and the lusterless immobility of houses. Effects of vibration are as yet only partially obtained, owing to the roughness of his brushwork and the opaque colors, with as yet no hint of translucency. But the latent attributes of Impressionism were all there; the sunny vigor of each brushstroke lent tension to the whole, and above the dome of the Pantheon hovered the grey and silver tenderness of the Paris sky.

In that same year, 1866, Berthe Morisot produced her first masterpiece, a *View of Paris from the Heights of the Trocadéro* (J. T. Ryerson Collection, Chicago), painted just downstream from the Pont d'Iéna. She had by now subtly assimilated the lesson of Corot, and her very original sensibility, bold and

refined at once, was asserting itself. Exquisitely colored and firmly constructed, this work was shown at the 1867 Salon, where Manet was so struck by it that he made a picture on much the same theme (National Gallery, Oslo), but with a more abruptly rising foreground peopled with many figures: a small boy walking his dog, a woman riding by on horseback, a gardener watering the lawns, police officers in cocked hats, fashionable women with sunshades, odd groups of strollers, with the rotunda of the Paris World's Fair looming up in the distance. In the following year, 1868, Berthe Morisot became Manet's pupil, which speeded up her growing tendency to use bright colors as he did.

Renoir enjoyed the best of his impressionist period in the years 1872-1880, when he was an incomparable interpreter of Paris, of her quays, bridges and boulevards. The scenes of Paris he painted prior to 1870 were still tentative efforts. His *Champs-Elysées* of 1867 openly harks back to Diaz and Corot; the *Pont des Arts* of 1868 falls into a dry and rigid pattern. His ice-skating scenes in the Bois de Boulogne of 1868-1869, though winter usually had a damping effect on his inspiration, display much more finesse and liveliness. Sisley exhibited two views of Paris at the 1870 Salon. Pissarro for most of his life remained faithful to the rustic tradition of Corot and the Barbizon painters; among his last works, however, were some views of Rouen and Paris, dynamic and brilliant canvases, brimming with the strong-knit vitality of his youth.

FIGURE-PAINTING IN THE OPEN AIR

ONET, Renoir and Bazille first tackled open-air figure-painting from 1865 to 1868, under the dominant influence of Courbet and Manet. After having been the place of election first of the romantic painters, then of the independent school of Barbizon, the Forest of Fontainebleau also became the background of the early impressionist experiments, whose most ardent initiator was Monet. "He became," writes Lionello Venturi, "the pacemaker of the Impressionists."

In 1863 he and Bazille spent their Easter holidays working together at Chailly-en-Bière, near Fontainebleau. Back again in 1864, after Gleyre's studio had shut down, they made a longer stay, accompanied this time by Renoir and Sisley. They painted forest interiors directly from nature, whose style and spirit, however, were still distinctly those of Barbizon. Lustily working away in his porcelain-painter's smock, Renoir attracted the attention of one of the artists he most admired, Diaz, who took him under his wing. From January 1865 on, Monet shared Bazille's studio in the Rue de Furstenberg, in the very house where Delacroix had died two years before. With the return of fair weather in April, he left Paris again for nearby Chailly, entirely absorbed in a new idea: to carry out a large figure composition, a *Déjeuner sur l'herbe* even bigger and bolder than Manet's, which he determined to paint entirely out-of-doors, in the attitudes most natural to picnickers on the grass.

Never before had an artist painted figures entirely in the open air; many had begun them outside, but all invariably repaired to the studio for the finishing touches. Impressed by the venture, Courbet went out to see "this outdoor painting"

GUSTAVE COURBET (1819-1877). THE VILLAGE MAIDENS (DETAIL), 1851. ▶
METROPOLITAN MUSEUM OF ART, NEW YORK.

40

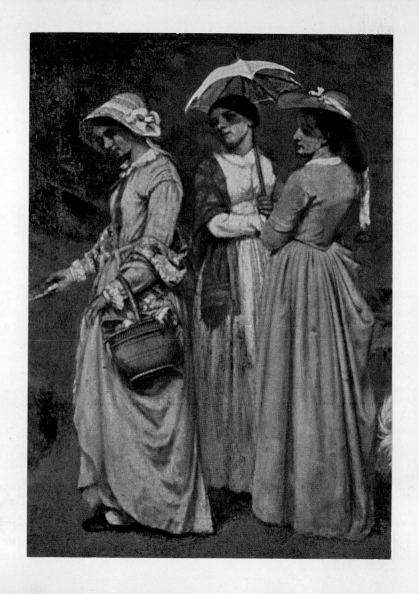

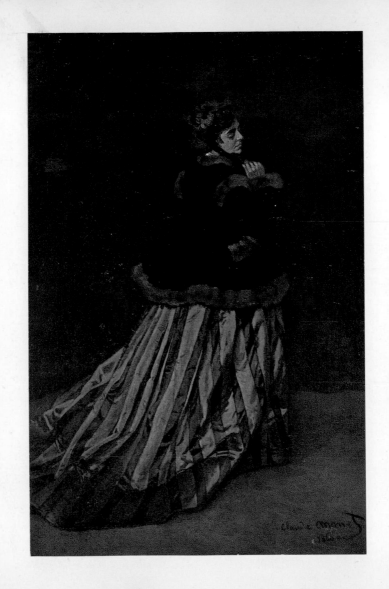

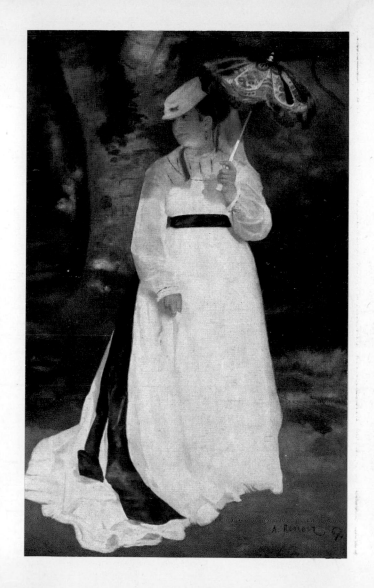

43

on the spot. The famous master and the intrepid beginner entered at once on the most cordial, the most fruitful of friendships, whose warm ties were strengthened by a long summer's work together at Trouville. Monet never forgot what Courbet had done for him. "Courbet," he wrote many years later, "has always been so kind and helpful to me, even tiding me over evil days with loans of money."

Early in 1866, as the Salon was about to open, Monet was putting the finishing touches on his *Déjeuner sur l'herbe* when Courbet advised him to make several last-minute changes. These he soon keenly regretted and, dashing off a portrait of Camille, his wife-to-be, sent this into the Salon instead, rolled up the large canvas by which he had set so much store, and left it in a corner of his room at Chailly. When he retrieved it later, damp and mold had eaten away the sides. These Monet slit off with a knife and the center fragment not only remains astonishingly fresh, graceful and natural, but forms a perfectly coherent whole. Light and shadows sweep freely and evenly round the still life, while the figures and leafage are built up solidly on scattered accents of color. Exquisitely graceful are the movements of the young woman in blue, standing erect, who has raised her arms and is about to doff her hat, and her companion in the center, with her flowing white dress spread out around her in full sunlight, who is holding out her plate at arm's length as if to offer the spectator a tidbit. The spleen with which Monet abandoned his *Déjeuner* only proved the depth of his feeling towards this canvas. From a practical point of view, the picture was a failure, but morally speaking it was

PAGE 42: CLAUDE MONET (1840-1926). CAMILLE, 1866. (89½×58½″)
KUNSTHALLE, BREMEN.

PAGE 43: AUGUSTE RENOIR (1841-1919). LISE WITH A SUNSHADE, 1867.
(71½×44½″) FOLKWANG MUSEUM, ESSEN.

a victory for Monet; it was his proclamation—at the tender age of twenty-five—of open-air painting as the supreme law of a revolutionary technique.

Having sent into the 1866 Salon his portrait of Camille, also known as *The Green Dress* (Bremen Museum), he saw it purchased by the writer Arsène Houssaye, while its praises were sung by a young critic reviewing the Salon that year for the first time: Emile Zola. No less enthusiastic was the appraisal of so seasoned a critic and connoisseur as Thoré-Bürger: "I don't mind telling the judges that this opulent painting was turned out in the space of four days. They were young, it was lilac time, out they went instead of remaining shut up in the studio. The Salon would soon be opening. There was Camille, a bunch of violets in her hand, with the lawn-colored train of her dress and her velvet jacket. From now on she is immortal and known as *The Woman in the Green Dress*." About to pass by, she turns and lingers for a moment, and this is the moment Monet has seized on, with an easy, felicitous touch that is usually likened to Manet's style. Actually it is patterned on Courbet's and brings to mind the woman in a crinoline robe and a Cashmere shawl who stands on the right in *The Studio*.

Comparison is also called for with Renoir's *Lise* (Folkwang Museum, Essen), painted out-of-doors in 1867 in the Forest of Fontainebleau and shown at the 1868 Salon, where it was admired and praised by Thoré-Bürger and Castagnary. Hervilly wrote a quatrain on it and Zacharie Astruc made the following comment: "Lise is wearing a fetching summer hat and a white dress held in at the waist by a black sash. A parasol shades her face. She stands still on the edge of the forest, in a sunlit clearing, and seems to be waiting for someone. This figure is happily rendered. The painting is attractive in every way: accuracy of effects, a delicate range of colors, unity and vividness of impression, excellent distribution of light. This art looks so

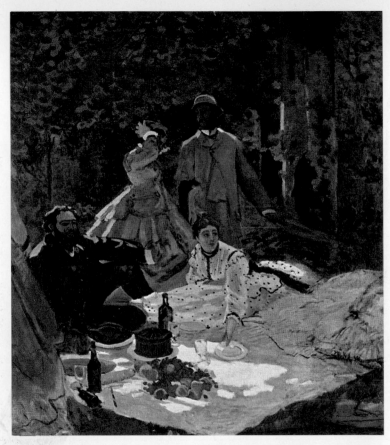

CLAUDE MONET (1840-1926). LE DÉJEUNER SUR L'HERBE, 1865-1866.
(97¼×85¼") PRIVATE COLLECTION, PARIS.

This is the sole surviving fragment of a vast composition painted in a
clearing of Fontainebleau Forest. The preliminary sketch is at the Museum
of Modern Western Art, Moscow. Replete with power, grace and freshness,
this work is young Monet's outspoken manifesto in favor of light and air.

In this vast open-air composition, his masterpiece, Bazille grouped together all the members of his family on the terrace of their estate at Méric, not far from Montpellier, in Languedoc. The figures in this large fragment from the right—the artist's brother and his wife, and a young cousin in a pale blue muslin dress—show inscrutable faces. All lean tensely forward as if hanging on the intrusion of a stranger in their midst. Each is very much a portrait, distinct from the whole. Forms hold their own in the virulent southern sunshine, not yet melting away in typical impressionist fashion.

FRÉDÉRIC BAZILLE (1841-1870). FAMILY REUNION (DETAIL), 1867-1869. LOUVRE, PARIS.

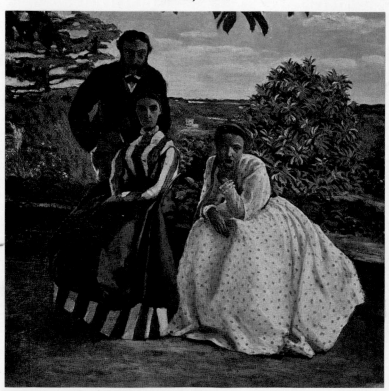

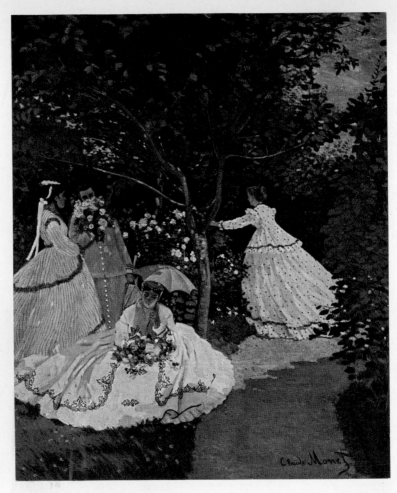

CLAUDE MONET (1840-1926).
WOMEN IN THE GARDEN, 1867.
LOUVRE, PARIS.

simple, yet how rare it is, how rewarding to study! It would have been impossible to put more candor than this into a theme whose entire charm stems from light. The whites, seen in full sunlight, are delightful." Again the general pattern derives from Courbet, from the middle figure of one of his most successful works, painted in 1851 but re-exhibited precisely in 1867, *The Village Maidens* (Metropolitan Museum, New York); this figure is Courbet's own sister Juliette, seen in profile with her sunshade, in the same monumental pose as Lise, with the same delicate range of soft colors.

With the movement towards the out-of-doors, the sunshade appeared in the hands of all fashionable women, adding a novel note of charm to their toilet. Courbet was the first to take it up in painting and the Impressionists at once divined the delightful effects to be got from its graceful form and bright colors. The contrast struck by the broad black sash girdling Lise's white muslin dress might smack of Manet, were it not for the smooth, vaporous modeling of forms, so utterly alien to the artist who painted *The Fifer*, while Renoir's unrivaled delicacy of touch—nothing in Courbet can compare with it—works wonders in shadings from tone to tone, in the gossamer-like caress of muted greys and blues on face and shoulders.

A furtive silhouette, with no hint of relief or modeling, Camille passes by and glides away without looking back, an elusive twinkling of sunbeams in the folds of her skirt. Lise steps pensively forward and pauses on the border-line of shadow and sunlight, her figure full-blown and opulent, with all the cocksureness of a girl of the people, yet as unreal as a dream, remote beneath the reflected gleams that swim around her. If Monet remained indifferent to the fine, full-bodied volumes Courbet relished, not so Renoir; he exulted in the same fullness of figures, sensual but lightly handled, and integrated into the shifting woof of light-and-shadow play.

Midway between *Camille* and *Lise* stands Monet's large *Women in the Garden* (Louvre), executed in 1867 at Ville-d'Avray. So as to reach the upper register without straining himself, he had a trench dug in his garden into which, by means of a pulley and cord, he could lower his canvas at will, to the utter amazement of Courbet, who stood by watching these unheard-of operations. Though Courbet is rightly regarded as an open-air painter, the entire body of his work drawing sustenance from nature and breathing the full draught of nature's power and savor, still the fact remains that his landscapes and *a fortiori* his figures were always finished in the studio. Hence, all too often, the jarring discrepancy between the "studio piece" and the rest, as in his *Village Maidens* for example, in which the women have obviously been stuck on to the landscape background, to which they only adhere by virtue of the exceptionally velvety texture of the colors. Of all the Barbizon painters, in fact, Daubigny alone saw the picture through on the spot, in front of the motif. Even Monet's *Déjeuner sur l'herbe*, owing to its unwieldy size, had to be moved into the studio for the finishing touches.

Women in the Garden, then, stands as the first large-scale figure-painting executed from start to finish in the open air. Its revolutionary character in fact was so pronounced that it was rejected outright at the 1867 Salon. Monet got the idea for the picture from a photograph and Camille took the pose for each figure successively out-of-doors. Thus once again he opened up an entirely new theme, that of garden spots in springtime, the quiet pastimes of a bourgeois afternoon, and in this atmosphere blossomed the Impressionists' finest, most characteristic works, which sealed the doom of traditional conceptions of form and color. Blue and green shadows flicker across faces in full sunlight, and women's silhouetted forms, unmodeled and volumeless, encased in white, tapering,

A composition of great originality, skillfully blending the garden land-
scape, figures out-of-doors in modern dress, and the seascape. Ringed round
with flowers, while atop their poles two flags flap in the wind, and two
or three vacationers pass the time of day in the sunshine, the terrace opens
out on the expanse of sea, across which plies a string of tramp steamers
whose skyward curling smoke mingles with fair weather clouds. Nearer
shore are several sailboats tacking into the wind. We can almost scent not
only the stiff ocean breeze, but the fragrance of the flowered terrace.

CLAUDE MONET (1840-1926). TERRACE NEAR LE HAVRE, 1866.
(38½×51″) REV. T. PITCAIRN COLLECTION, BRYN-ATHYN, PA.

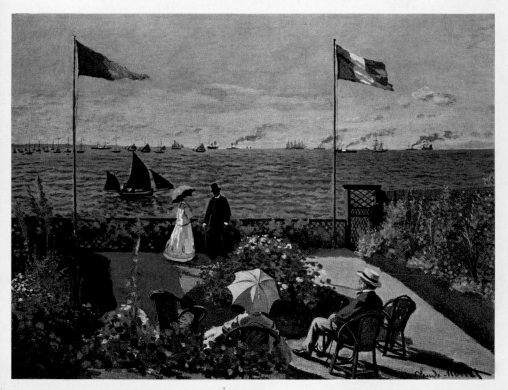

corolla-shaped dresses, flit amid the flowers and lend all their grace and animation to a light-filled paradise—such is Monet's *Women in the Garden*. The entire composition glows with light, which, however, is still no more than a surface light to which forms are still impermeable, though the picture as a whole, aglow with all the unity of a perfect decoration, boldly sets the stage for the impressionist scenes soon to come. Painted in the same vein the previous year, alive with flapping streamers and particolored flowers, flooded with light, Monet's *Terrace near Le Havre* (T. Pitcairn Collection, Bryn-Athyn, Pa.) opens out triumphantly on a far-flung seascape that blends perfectly with the figures moving in the foreground.

Degas was a painter of interiors, Sisley a landscape painter exclusively, while Pissarro made no attempt at figure-painting prior to 1870. Bazille's art is harder to assess, as he was killed in action in the Franco-Prussian War and all we have to go on are the highly eclectic works of his youth. Of these by far the most significant are the figure compositions, executed, like Monet's, in the open air either at Fontainebleau or, more often, on the family estate at Méric, near Montpellier, where he returned each summer. The largest and most ambitious is his *Family Reunion* (Louvre), painted in 1867 and slightly revised in 1869. It is closely akin to *Women in the Garden* in the accuracy and brightness of the open-air atmosphere and the elegance of the women's dresses, worlds apart from it in the motionless blaze of southern light, crystal-clear and virulent, the clean-cut volumes of each form, the impression of austerity that arises from this silent, closely packed group. Dressed in their softly rustling skirts of pale muslin, gracious young ladies, Bazille's sister-in-law and cousin sit on a low wall to the right, looking anxious and inquisitive. Owing to this moral reserve and his classical stability, Bazille diverges from the main stream of Impressionism, naturally sensual and mobile.

JAPANESE PRINTS AND PHOTOGRAPHY

IMPRESSIONISM was the progressive conquest of light taken as the vital principle of painting, and its natural field of action and growth was the landscape, in which contours melt away in the intense vibration of the atmosphere. But experiment with light and color is not the whole story of the movement, and the great many figure-studies made before 1870 set absorbing problems of form, space and composition that clamored for solution. The result was a fresh way of looking at the world, encouraged in its boldness by the contemporary vogue for Japanese prints and new developments in photography.

For nearly a century, art revolutions have tended to take their stand on some long-established style, archaic, exotic or primitive in nature. For the generation of Manet, Degas and Monet, the charm of Japanese art lay in its decorative spontaneity, its lively, ironical way of breaking down the world in terms of linear and chromatic harmonies, its rapidly shifting contrasts of brighter and darker values. For the post-impressionist generation of Lautrec and Gauguin—pending the day when Bonnard and Vuillard were to infer very different lessons from them—Japanese prints stood on the contrary for sharp silhouettes and a dynamic concentration of expressive lines binding pure, flat colors. Perhaps their most decisive influence was brought to bear on Van Gogh, who, at the turning-point of his career, discovered in Japanese art the "true religion" whose creed he exulted in when at last he reached Provence, for him the "equivalent of Japan."

PAGE 54: ÉDOUARD MANET (1832-1883). OLYMPIA (DETAIL), 1863. LOUVRE, PARIS.

PAGE 55: ÉDOUARD MANET (1832-1883). PORTRAIT OF EMILE ZOLA (DETAIL), 1868. LOUVRE, PARIS.

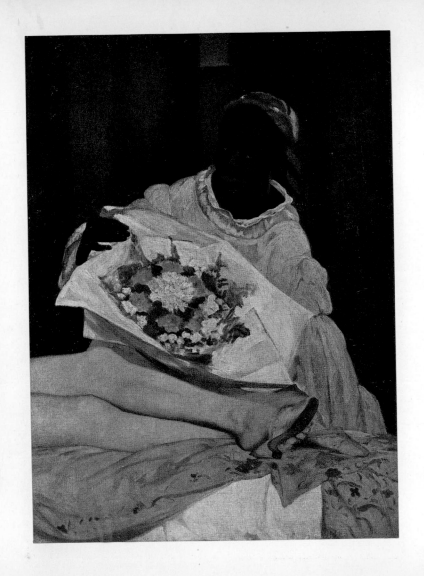

When Japan resumed commercial relations with the west in 1854, after centuries of isolation, her wood-block prints began to appear abundantly in Europe in the form of wrapping paper. So it was that the engraver Bracquemond discovered Hokusai in 1856. In 1862 Madame Soye, a French lady who had lived in Japan, opened up an oriental shop, "La Porte Chinoise," under the arcades of the Rue de Rivoli, and it promptly became a gathering-place of such painters and writers as Manet, Fantin, Tissot, Degas, Baudelaire and the Goncourt brothers, all of whom were soon adept at distinguishing things Japanese from things Chinese and eagerly set to collecting them both. Soon widespread, the vogue fed on an influx of books on the subject and the presence at the Paris World's Fair of 1867 of a large oriental pavilion. At the 1865 Salon Whistler exhibited his *Princesse au pays de porcelaine*, a highly refined, decorative portrait of his mistress wearing Japanese costume; Whistler himself posed in a kimono for Fantin's *Toast*. But this was the superficial side of the cult inspired by the Japanese. Manet, Degas and Monet looked to Japanese art for deeper, more lasting lessons that fell into line with their own researches: Monet, for a new limpidity, brightly flung shadows, a system of shortcuts and syntheses; Degas, for asymmetrical lay-outs, bold foreshortenings and plunging lines of sight, figures thrown out of balance, cut off at the edge of the picture, shown in vivid and intimate close-ups (e.g. his fine *Portrait of Madame Camus* of 1870); Manet, for tension and contrast between dark and light surfaces, the terse color sonority that uplifts and crystallizes *Olympia*. The dark hand of the Negro mammy against the whorl of white paper wrapped round the ceremonial bouquet strikes a chord whose sublime pitch is in all respects worthy of Velazquez and Utamaro, each in his own way, both of whom flank *Olympia* on the back wall in the *Portrait of Zola* (1868) and symbolize the opposite poles to which Manet was attracted.

EDGAR DEGAS (1834-1917). PORTRAIT OF MADAME CAMUS (DETAIL), 1870.
CHESTER DALE COLLECTION, NATIONAL GALLERY OF ART, WASHINGTON.

But the Japanese print stood in relation to these artists just as Negro sculpture later did to the Cubists, and as does any serious influence to genuinely creative artists: it was less a source of direct inspiration than a catalytic agent speeding up an inevitable chain of reactions. In a series of articles on *Japan in Paris* published in the *Gazette des Beaux-Arts* as early as 1878, the critic E. Chesneau gave a first-rate analysis of the debt owed to Japanese art by each of the great artists of the day: Whistler "the exquisite niceties of his color-schemes," Manet "the easy freedom of his color-patches," Monet "the curt omission of detail in the interests of an over-all impression," Degas "the realistic fantasy of his figure-groups." And he aptly concluded: "Rather than an inspiration, all of them found in it confirmation of their own personal way of seeing, feeling, understanding and interpreting nature. Hence the redoubled originality of each instead of a meek submission to Japanese art."

Though much less stress has been laid on it, the role of photography was an equally important factor, and equally indirect in its influence, since after all the camera eye is focused by the operator and necessarily guided by his tastes and ideas. The first snapshots appeared about 1863, aerial and stereoscopic views about 1865, and a comparison of these with contemporary pictures is enlightening indeed. In Manet's *View of the Paris World's Fair* we can make out on the right the stand got up by the well-known photographer Nadar, a great friend of the Impressionists, in whose studios they held their first group exhibition in 1874. Degas proved most adept at capitalizing on the lessons of photography, using close-ups, plunging lines of sight and unexpected angles of vision and perspective to great effect. But far from forcing him into strictly mechanical patterns of vision, the camera merely hastened and confirmed the natural evolution of Degas' style, consolidating his keenly analytical, psychological approach to the world.

BLACK AND WHITE
SNOW AND SHADOWS

ONLY from 1873 on did Manet, Degas and Cézanne begin to use a really bright palette, and only from then on did Monet, Renoir, Pissarro and Sisley do away with low-toned shadings of intermediate greys and browns in favor of the vibrant exaltation pure colors alone afforded.

Without a peer prior to 1870, Manet's painting was based primarily on the contrast of whites and blacks juxtaposed in full shadow or bright light with unrivaled elegance and freedom. The vivid, pre-eminent silhouette of Berthe Morisot, who posed regularly for Manet before becoming his sister-in-law in 1874, rose to perfection several times on a tide of majestic contrasts, empyrean whites and greys barely tinted with pink and blue standing against the inimitable black celebrated by Baudelaire, Mallarmé and Valéry. "Before all else," wrote Valéry, "black, sheer black, the black of a mourning hat whose laces mingle with strands of auburn hair tinged with pink, the black that is Manet's alone, seized and held me..." In his *Portrait of Berthe Morisot*, the hat is a crown of white plumes beneath which dark curls straggle over her shoulders.

Though on good terms with his comrades and familiar with the researches of each, Cézanne worked in seclusion and had no share in this pre-impressionist phase. In 1866 he wrote to Zola, his boyhood companion: "All the pictures done inside, in the studio, will never be worth the things done out-of-doors. I must gird myself to do nothing but open-air work." His passionate southern temperament reminiscent in many ways of Daumier's, his obsession with romantic themes taken over from Delacroix, and his numerous "irrepressible inhibitions" led Cézanne to seek relief in highly imaginative scenes fraught with sensual violence, treated in a thick, overwrought impasto full of

CLAUDE MONET (1840-1926). THE PHEASANT, 1869. (16×31")
PRIVATE COLLECTION, NEUCHATEL (SWITZERLAND).

expressionist distortions. In 1869, owing perhaps to the new stability of his emotional life brought about by his liaison with a young model, Hortense Fiquet, his wife-to-be, he fell under Manet's beneficent influence. The immediate upshot was an unqualified masterpiece, *The Black Clock*, a still life in which now at last the subject is nothing and the sovereign harmony of the colors everything. An undercurrent of passion lingers on, but overmastered, gravely inherent in the stately rhythm of forms and colors, the silent flow of blacks and whites streaked with fleeting accents of blue, red and yellow.

At the same time Monet, Pissarro and Sisley reveled in winter landscapes with snow, not only because these supply the painter with nature's finest harmonies of blacks and whites against lead-grey skies, and not only because snow provides an

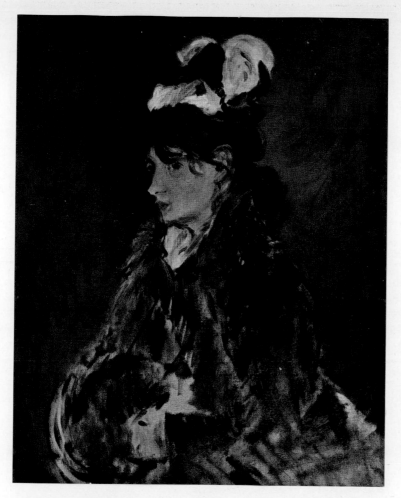

ÉDOUARD MANET (1832-1883). PORTRAIT OF BERTHE MORISOT, 1869.
(29×23½″) LEONARD C. HANNA JR. COLLECTION, NEW YORK.

ideal background for subtle variations of color, playing the same role for landscapes as white tablecloths do for still lifes (and Monet's *Pheasant*, just such a still life, dates precisely from 1869), but also because the impinging rays of the sun played off against an expanse of snow gave them a unique opportunity to observe and analyze *colored shadows*, which they found to be a true natural phenomenon and took as one of the fundamentals of their style, thus freeing themselves entirely of the time-honored conventions attaching to chiaroscuro and local colors. While striving to render the natural intensity of sunlight glinting on snow, they suddenly realized that pure colors, though less brilliant than white, gave a truer idea of shimmering light than white did. They further realized that nothing in nature casts absolutely black shadows, that every shadow bears its color and respects the law of complementary colors. Their study of snow it was then, paradoxically enough, that led them to give up those contrasts of blacks and whites, even of intermediate shades of grey and brown, on which their pre-1870 technique was based; from that date on they worked more and more in terms of the pure colors of the prism.

The Japanese and the 17th-century Dutch painters were also masters of the snowscape, a theme they all took obvious pleasure in. Quite neglected by Corot and the Barbizon school, however, it had nearly been forgotten when Jongkind and above all Courbet finally retrieved it. While wintering in the Jura country, where he was born and bred, Courbet painted many scenes of dead game limply huddled on the snow, impeccably executed though sometimes noticeably over-dramatized, as well as many straightforward snowscapes, unassuming, introspective scenes in which nature is plumbed to the depths of her silent inscrutability; the latter are masterpieces of the first rank, though in them no attempt is made to analyze the play of light. Monet painted his first snow scenes at Honfleur

Under the salutary influence of Manet, Cézanne achieved his first master-piece in the field of the still life, on which he conferred a grandeur and magnitude it had hardly enjoyed for generations. At long last he had outgrown the erotic romanticism of his youth, wholly absorbed now in the austere and stately rhythm of a composition surprisingly small in size, yet monumental in its muffled power and concentration. Forms and colors well up like lava-flow, alternately light and dark, relieved with accents of blue, pink and red, while the intricate volutes of the large shell temper the contrasting architecture of horizontals and verticals.

PAUL CÉZANNE (1839-1906). THE BLACK CLOCK, 1869-1870. (21¼×28¾″)
NIARCHOS COLLECTION, PARIS.

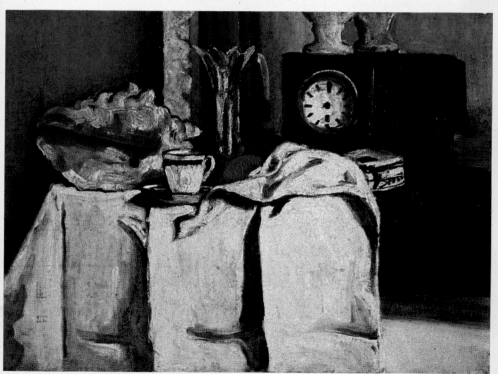

about 1865, e.g. *The Cart* (Louvre), in which, beneath a veneer of realism, we feel the first delicate stirrings of atmospheric light. Above all during their stay in England in the winter of 1870-1871, the climate as well as the example of Turner bending their thoughts in this direction, Monet and Pissarro painted whole sets of snowscapes. Not having made the trip to London

CAMILLE PISSARRO (1830-1903). SNOW AT LOWER NORWOOD, 1870. (16×20¼″) COLLECTION OF LORD RADCLIFFE, LONDON.

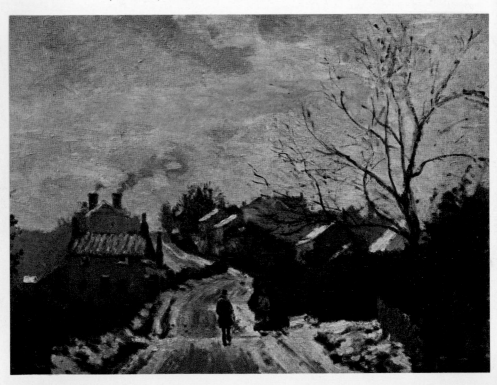

and loathing winter, moreover, as nature's season of mourning, Renoir was alone in ignoring a theme that, from this time on, was the delight of his friends in the exercise of their color talents. Winter in fact almost triumphed over springtime in their favor, and Sisley in particular found in snow the ideal motif for the exquisite refinement and accuracy of his palette.

ALFRED SISLEY (1839-1899). SNOW AT LOUVECIENNES, 1870. (21¼×28¾″)
JOHN P. SPAULDING COLLECTION, MUSEUM OF FINE ARTS, BOSTON.

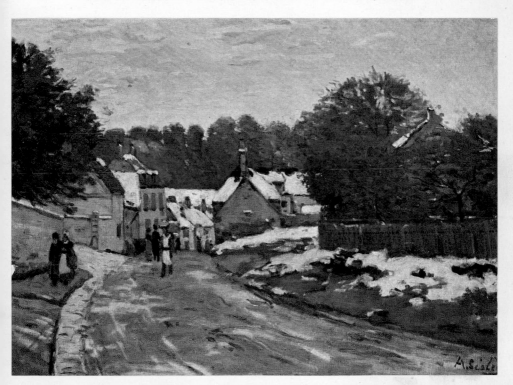

COROT AND LANDSCAPE

THE two early groups that had spontaneously formed—one at Gleyre's studio around Monet, the other at the Académie Suisse around Pissarro—exactly corresponded to the two distinct branches of Impressionism at Argenteuil and Pontoise: one visionary and cosmic in outlook, haunted by rippling waters and twinkling lights, the other bucolic and earthy, concerned with constructive values and true to the spirit of Corot.

If, however, the decisive influence of Daubigny, Jongkind and especially Courbet on the early course of Impressionism can easily be traced, almost step by step, as the plates in this book show, Corot's influence was much more diffuse; it was in fact a moral force at least as much as a technical lesson. For all he remained "le père Corot," a spiritual guide, wise and kindly, looked up to with unmingled veneration. As naïve as a child, angelic in his kind-heartedness, he is the purest example in painting of the *natural way of seeing*, clouded over in Constable with moralizing and quaintness, in Courbet with social ideas, in the Barbizon painters with romanticism and melodrama. Corot instinctively embraced the aesthetic whose broad lines stretched farthest into the future, the aesthetic that made of art the voice of the artist's innermost feelings. The secret of this way of seeing was summed up many times by Corot himself in pithy, crystal-clear observations in which the word "impression" not only gets its full meaning for the first time but recurs with the regularity of a leitmotiv: "Always the mass, the whole, that which particularly strikes us. Never lose the first impression by which we are moved." Or again: "*Give in to the initial impression.* If we have really been touched, the sincerity of our feelings will be communicated to others." And this summing-up, the supreme counsel he had to give: "Being oneself is the only way to move others."

In those first fine "studies" made in Italy in 1825, with their scrupulous limitation of the motif, the limpid clarity of the atmosphere, the vitality of the drawing, the shifting patterns of shadow and light, he straightaway burst the cramping bounds of neo-classic, romantic and realist tastes. Deliberately checking flights of fancy and limiting his palette to a narrow range of colors, but exacting the utmost firmness and density from each, he posited then and there the guiding principles of a spontaneous form of Impressionism that was not to be consciously practised until fifty years later, in 1875, the very year of his death. And on his deathbed, as if divining the new art on the rise, he confided to his friend Robaut: "You have no idea how differently I see things now... I never learnt to do a sky. What

CAMILLE COROT (1796-1875). SAINT-ANDRÉ-DU-MORVAN, 1842.
(11¾×23¼") LOUVRE, PARIS.

"This artist is concerned solely with the truth... Standing in some corner of nature, he interprets the horizons before him in their broad severity, with no attempt to work in any tinsel of his own devising. Neither poet nor philosopher, he is simply a naturalist, a contriver of skies and landscapes. Entertain dreams if you like, he straightforwardly shows you what he sees. His is a deeply human originality. It lies in the stuff of the artist's temperament. Never have pictures seemed to me so masterly in their amplitude. Such reality as this is loftier than dream" (Zola on Pissarro, 1868).

CAMILLE PISSARRO (1830-1903). LA COTE DU JALLAIS A PONTOISE, 1867. (34¼×45¼") METROPOLITAN MUSEUM OF ART, NEW YORK.

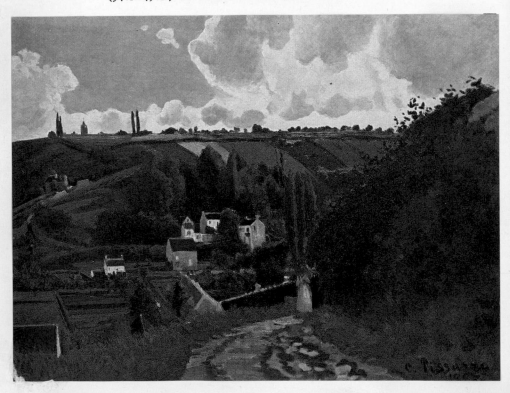

I see before me is much pinker, much deeper, much more translucent. How I should like to show you the depths of these immense horizons!"

Pissarro came to Paris in the last days of the 1855 World's Fair. He wandered through the galleries crowded with the exhibits of Ingres, Delacroix and Théodore Rousseau, tarried in Courbet's private pavilion, and noticed Daubigny's work. But when he saw the landscapes shown by Corot, he stopped short. This was the decisive moment for Pissarro, his deep affinity of temperament and vision with Corot charting out the course of his entire career. Overcoming his shyness, he paid a visit to the man whose work so much attracted him, then still dismissed as a second-rate painter, and a "clumsy" one into the bargain, because he confined himself to landscape and left his pictures "unfinished" by the standards of the smooth and polished academicians of the day. Corot received his caller with the same open-hearted kindliness with which he welcomed every sincere young artist who came to him for advice, and impressed him with two principles Pissarro was never to forget: form and values, i.e. structural solidity and accurate lighting. He presented him with a drawing, not a summary working sketch for one of the pictures he had on the stocks at the time, but a study dating from 1836, a view of the countryside near Montpellier (now in the Metropolitan Museum, New York), worked out in every detail, yet full of air and space, in which all the elements of the landscape, trees, rocks and river, fall into place with the same freedom, inevitability and cohesion as in nature herself. Though on the friendliest terms with Monet from 1859 on, Pissarro never joined in his expeditions to the Channel coast where the sea light and boundless horizons interfered with the order and stability he craved. Pissarro felt at home only in the countryside around Paris, at Montmorency, La Varenne-Saint-Hilaire, La Roche-Guyon, Louveciennes and Pontoise, in the

ARMAND GUILLAUMIN (1841-1927). MONTMARTRE, 1865. (21 ¼ × 25 ½″)
PRIVATE COLLECTION, GENEVA.

soft, radiant light of the Ile-de-France. Two motifs inherited
from Corot found most favor with him: houses huddled against
a hillside and country roads winding away in perspective.

Castagnary noticed the work he sent in to the Salon des
Refusés in 1863 and warned him against a docile surrender to
Corot. Pissarro's originality shone through even then, however,

in textural effects obtained with a liberal use of the palette knife, after the manner of Courbet, a technique rich in both dense and refined contrasts to which Cézanne also resorted. Pissarro exhibited at the official Salons of 1864 and 1865 as "Corot's pupil." In 1866 his *Banks of the Marne in Winter*, the first really original picture he produced, caught the eye of Zola, who warmly praised it. That same year he settled at Pontoise, where the hill of The Hermitage, massive and compact, became the theme of election answering in every way to the structural coherence of his style and the subdued vitality of his palette. Compare *La Côte du Jallais* (1867) with that admirable masterpiece

ALFRED SISLEY (1839-1899). VIEW OF MONTMARTRE, 1869.
(26¼×45½") MUSÉE DE GRENOBLE.

Hollowing out and organizing space in the classical manner—the classic example being Hobbema's *Avenue of Middelharnis* (National Gallery, London)—such roads as this, running out to the vanishing point, recur frequently both in the works of the Barbizon painters and in Corot's final period. Here, as in all Corot's late work, we find the patterns of cast shadows, the presence of human figures and animals, the finely shaded, velvety texture of the light. The tilt of the road enables Corot to do away with the traditionally conspicuous foreground and pierce to the heart of the landscape. With the single exception of Monet, all the Impressionists found this practice to their liking, particularly Pissarro, who made much of it during his two stays at Louveciennes before and after the Franco-Prussian War, when the house he lived in stood at the side of the road.

CAMILLE COROT (1796-1875). THE SÈVRES ROAD, 1855-1865.
(13¼×19½″) LOUVRE, PARIS.

by Corot, *Saint-André-du-Morvan*, dating from 1842, i.e. from Corot's severest, most constructive period, prior to his third trip to Italy; the originality and self-mastery of the younger man are obvious. Pissarro retained all Corot's structural solidity —we might almost say his "organic soundness"—, his well-organized planes and volumes, the frankness and rigor of his vision, the muffled austerity of his color-schemes. But, above and beyond this, he vitalized the picture-surface with a light, aerial hint of stir and animation that produces an "atmosphere" less dense, less dependent on the fixity of the motif.

In 1869, following the lead of Monet and Renoir who were painting at the Grenouillère, Pissarro set to work at Bougival. As he studied the play of sunlight on the Seine, his composition loosened up to its advantage, grew more fluid and graceful. In 1870 he produced a set of masterpieces on the theme of roadways seen in perspective, which he had taken over from Corot (e.g. *The Sèvres Road* in the Louvre), an intimate concentration of all the order and poetry in nature. We find it frequently in Renoir, Sisley and Cézanne, but seldom in Monet, who preferred the sheer breadth of space and nature to a deep corridor of space. *The Diligence at Louveciennes*, as seen by Pissarro, moves dismally ahead on a sopping, muddy highway in a late-autumn rain. The glistening patterns of light and shadow with which he had experimented the previous year on the waters of the Seine are convincingly applied here to patches of ground, to trees and houses; they constitute the basic element of this marvelous picture, whose colors are still the greys and browns of Corot skillfully shaded, with scattered gleams of pink, green and violet peering through. Reviewing the 1870 Salon, the young critic Théodore Duret wrote: "Pissarro got his start painting landscapes that badly lacked light, their general tone usually being dull and lusterless. Today he has grown bolder, so much so that his recent pictures and particularly those at

this year's Salon seem to mark a great step forward... In one sense Pissarro is a realist. He never composes a picture and, in his landscapes, never arranges nature. For him a landscape on canvas must be the exact reproduction of a natural scene and the portrait of some spot in the world that really exists... But if Pissarro is a realist in his determination to reproduce exactly the scene before him, he is not a thoroughgoing realist in the sense that certain other painters are, who see no more than the externals of nature, without fathoming its soul and its innermost meaning. On the contrary, he stamps his every canvas with a feeling for life, and as we gaze at even the most ordinary scene painted by him, a highway lined with elms or a house nestling beneath leafy trees, we feel a sense of melancholy stealing over us, the same he must have felt himself as he stood before the scene."

Until 1870 Sisley painted more or less as a dilettante and few of his early canvases survive. Most characteristic of them, perhaps, is the Montmartre landscape (1869) in Grenoble Museum. Montmartre at the time was still a rambling village perched on a hill behind Paris. Its old windmills and its mixed character, half rustic, half citified, threw a spell over the Impressionists, all of whom stayed there at one time or another, after Jongkind had shown the way. As we see by the choice and layout of the subject, as well as the extreme delicacy of the colors, still abiding by local tones, but alive and quivering with light, Sisley upheld the tradition founded by Corot, whose pupil he loyally declared himself to be and with whom he kept faith all his life, notwithstanding the strong attraction Monet exerted on him. An early view of Montmartre by Guillaumin, a close friend of both Cézanne and Pissarro, also dates from the sixties; with its fenced-in gardens, the picturesque alleyway, the irregular spacing of houses and its density of texture, this canvas stands midway between Corot and Utrillo.

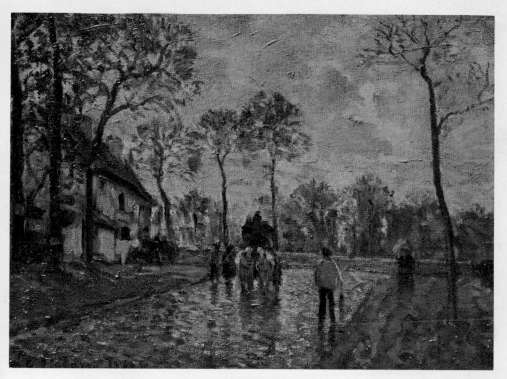

CAMILLE PISSARRO (1830-1903). THE DILIGENCE AT LOUVECIENNES, 1870.
(9¾ × 13¼″) LOUVRE, PARIS.

To the trim perspective lines and vanishing point of Corot's roads, which
disappear in floating haze, Pissarro generally preferred roads that wind
away in perspective or slew off to one side, which better concentrate the
constructive elements of space, organize the criss-crossing of shadows
and lights, and focus the eye on the middle distance. Drawn by two white
horses, the stagecoach has nearly bogged down in the glistening sludge of
the highway. The background is cut off by a thick line of trees running
lengthwise across the canvas. On the left, the massive weight of the house
is stressed by slim, graceful trees that lift their balding tufts into a lurid sky.
Greys and browns convey the melancholy of fine rain at dusk in autumn.

THE SEINE BANKS

AFTER trying his hand at landscapes, seascapes, still lifes, street views of Paris and large figure compositions in the open air, Monet settled on the banks of the Seine in 1869, where he hit on the theme that emblemized Impressionism.

Whereas the Channel beaches had become the exclusive reserve of wealthy society-goers, Parisians of all classes were free to enjoy the outlying villages and pleasure-spots of the Ile-de-France, thanks to the newly built railways which took them out in a few minutes to shady nooks, quiet waters on the Seine and Marne, and colorful *guinguettes* where dancing and amusement were cheap and plentiful. Canoeing, too, was a favorite pastime among many described in that precious log-book of contemporary life, the Goncourt brother's *Manette Salomon*. The painters took part in these outings, to which their youth and good spirits joyfully responded. During the summer of 1869 Monet worked at Bougival, where he was often joined by Renoir, then living with his mother at nearby Ville-d'Avray. Only a few miles outside Paris, Bougival was then at the peak of its popularity. The two painters dropped in regularly at the inn and restaurant run by "la mère Fournaise" at Croissy, on the opposite bank, where Renoir often returned in after years. They spent days on end painting together at La Grenouillère, a popular bathing spot on the Seine, where only a few years later Maupassant was to locate several of his short stories: "Round about the Grenouillère a throng of strollers wound among the giant trees that make this end of the island the most delightful spot in the world." Monet and Renoir each made several pictures of the landing-stage here, with the tall shade-tree that stood beside it, laughing groups of canoers at the water's edge, gaily dressed girls on the shore, and broken gleams of sunlight flashing through the foliage, dancing on the water.

GUSTAVE COURBET (1819-1877). GIRLS ON THE BANKS OF THE SEINE, 1856.
(68×81″) MUSÉE DES BEAUX-ARTS DE LA VILLE DE PARIS.

Meticulously worked out beforehand in many studies of details and two complete preliminary sketches, this admirable composition was one of the most influential single factors in the rise of Impressionism and the migration from the studios to the open air and the authentic light of day. Painted in the fifties, it was re-exhibited, significantly enough, in 1867. The plates on the next four pages vouch for its impact on Monet and Renoir. Two plump young women, feeling the fatigue of rowing and the heat of the day, rest in the shade on the cool banks of the river, one propped up on her elbow, the other dozing in chaste yet vaguely sensual abandon.

AUGUSTE RENOIR (1841-1919). THE BOAT, 1867. (9¾ × 13¼″)
PRIVATE COLLECTION, PARIS.

Obviously inspired by Courbet, this canvas is Renoir's first full-scale study of light-and-shadow play amid leafage and rippling waters as it flickers over a figure and becomes the unifying principle of the entire composition. In a light summer dress and a dark hat, having shipped the oars and fallen to dreaming, a young woman languidly sits in a rowboat that has drifted against the grassy banks, beneath a tree whose over-hanging branches gently skim the surface of the water and stir up glints of light. This canvas is an aggregate of lush, broad, unfused strokes, with dabs of red and light blue that "season" the dominant salad-green tonality.

Though roughly contemporary with Renoir's canvas, on the opposite page and, like it, based on gleams of reflected light, this picture displays notable differences both in technique and vision. Here the young woman is seated on the river bank, with the boat grounded in front of her. She seems less pensive than intent on the view on the opposite shore and the reflections in the water. Her gaze, felt rather than seen, is like the symbol of Monet's own eye and its acute powers of analysis. Instead of the distinctly circular rhythm of Renoir's *Boat*, here we have space conveyed by a succession of staggered planes, alternately light and dark, and subtly varied brushwork.

CLAUDE MONET (1840-1926). ARGENTEUIL-SUR-SEINE, 1868. (32×39″)
ART INSTITUTE OF CHICAGO. (PHOTOGRAPHED BY RICHARD G. BRITTAIN)

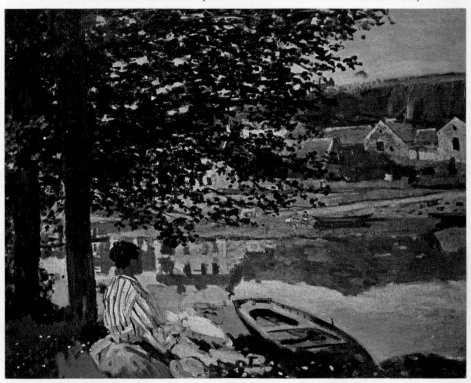

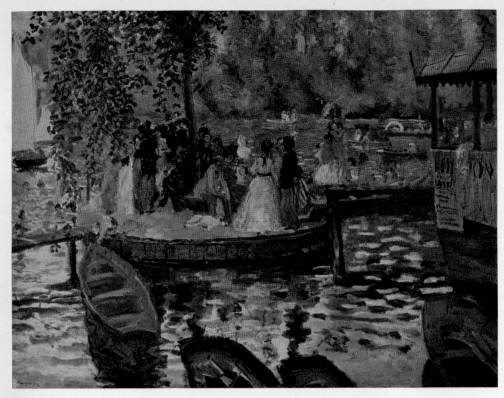

AUGUSTE RENOIR (1841-1919). LA GRENOUILLÈRE, 1869. (26×31¾")
NATIONAL MUSEUM, STOCKHOLM.

A popular bathing spot on the Seine, La Grenouillère turns up several
times in the novels of the naturalist writers, notably in Maupassant, who
describes it from his usual jaundiced viewpoint. Renoir, however, painted
only the happy, carefree side of summer days spent boating and swimming
there. Two other versions of the same scene are extant: one, similar to
this, in the Oskar Reinhart Collection at Winterthur, the other, quite
different, at the Museum of Modern Western Art, Moscow. Cool crystal-
clear light filters through the entire canvas in an all-pervading harmony
of tender green and blue-grey, lit up here and there with a brighter dab.

The Goncourt brothers commented as follows in their *Journal*: "Bougival, the landscape studio of the modern French school. Each bend in the river, each willow-tree, brings to mind an exhibition." Summering there in 1869, Monet produced this, his first thoroughly impressionist painting, for which he made countless preliminary sketches. It is more broadly, more powerfully scaled than Renoir's, but falls short of the latter's color harmony and unity of light effects. Fewer boats and fewer figures together with sparser foliage let a deeper breath of air into the picture, broaden the river and shift the stress on to the gleam and flicker of the rippling water.

CLAUDE MONET (1840-1926). LA GRENOUILLÈRE, 1869. (29¼×39¼")
METROPOLITAN MUSEUM OF ART, NEW YORK.

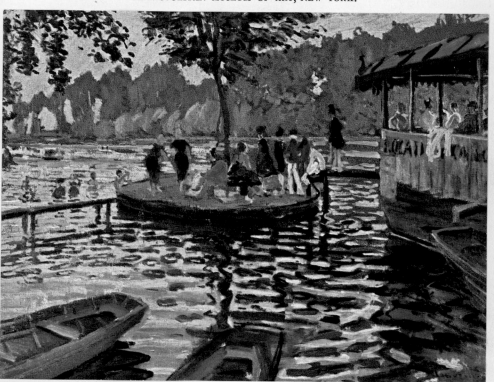

And so as to capture the uprushing dynamism and carefree gaiety of scenes that inspired them afresh each day, they soon found themselves spontaneously applying the future principles of the impressionist technique, all the more coherent now for having been latent in many previous works: the "comma" brushstroke, flickering dabs of pure color, the vibrancy of light. A new way of seeing arose that owed nothing to theory, but sprang from the direct observation of nature. Their technique lacked unity as yet, a mature style only being arrived at after 1873. But perhaps never again did Monet and Renoir quite match the intuitive freshness and sparkle of these early masterpieces, nor the fraternal exaltation comparable only to that which sprang up between Matisse and Marquet thirty years later, in 1899, when together they first began painting "fauve," unwittingly paving the way for the mature, systematic Fauvism of 1905.

These happy scenes of country revels that gave birth to Impressionism masked the day-to-day hardship these young men endured. Monet had even been driven to make an attempt on his life several months before. Living in the direst want with Camille and their two-year-old baby, he gladly accepted the bread offered them by Renoir, whose keep was provided him by his family, but who, like his friend, had to beg or borrow the money needed to buy his colors. On August, 9, 1869, Monet wrote to Bazille: "Dear friend, do I dare tell you what my plight is? Just ask Renoir who brings us bread from his own table..." Bazille at once responded with a fifty-franc note and a basket of grapes from his own vineyard for Renoir. On the 25th of September Monet again wrote to Bazille: "In despair. I sold a still life and could then work on for a while. But as usual I've had to call a halt for lack of colors. I alone shall have nothing to show for the year."

Nevertheless, in the interval between these two despondent letters Monet painted the wonderful *Grenouillère* now in the

Metropolitan Museum, New York. The golden ripples of the water and the vibrant splash of light that dominates the composition are forcibly rendered with a sure and confident hand. Renoir, too, made several versions of *La Grenouillère*. That in the Stockholm Museum was painted from almost the same angle as Monet's, perhaps the very same day as they worked side by side; it reveals less visionary power, but greater grace and lightness of touch. Monet took possession of space, vigorously juxtaposed flat dabs of pigment rich in texture; Renoir veiled the scene in a lambent halo of light, huddled the figures together, increased their number and size, smilingly lingered over a detail here and there, the dog lazily outstretched, the sweep of a dress, the white sail beyond the overhanging leafage, while bright accents of color enhance the subdued translucency of the whole scene. The same well-marked difference of technique and feeling between Renoir and Monet had already stood out in 1867-1868 in two figure-studies at the river's edge, *The Boat* (Private Collection, Paris) and *Argenteuil-sur-Seine* (Art Institute of Chicago); both women sit amid waving leafage and the shimmering ripples of the water, but one extraordinarily intent, the other lost in reverie. These two figures are like a prelude to the nautical scenes to come, and both hark back directly to that masterpiece by Courbet, *Girls on the Banks of the Seine* (Musée des Beaux-Arts, Paris), painted in 1856, but re-exhibited in 1867, when it enthralled the Impressionists-to-be, who borrowed the theme and embroidered on it for years.

Having settled in 1869 at Louveciennes, in the same neighborhood as Renoir and Monet, Pissarro threw all his energies into rustic themes and pure landscape. Even so, he could not quite elude Monet's influence and so in turn painted two versions of *The Seine Banks* in which the study of light gleaming on water impinges on the new unity of his style, but without impairing the organic amplitude of the composition.

ART CRITICISM AND ART LIFE
THE STUDIOS AND CAFÉS

IMPRESSIONISM was never a school of painters artificially banded together in support of a set program handed down from master to disciple. It arose spontaneously from the "chance" meetings, close personal ties and friendly give-and-take of a handful of gifted young artists who insisted on discovering the world for themselves. However dissimilar in background and temperament, nearly all the vanguard artists in France between 1860 and 1870 stood together to a man, not in obedience to any given principle but simply out of a common desire to express themselves freely and, following in the wake of Manet, to overthrow the conventional barriers of officialdom.

Their deep mistrust of city life and finespun points of theory, their love of the open country, their cult of independence and utter sincerity—all this Monet expressed in a letter to Bazille written from Fécamp in 1867: "We have been too much concerned with what we see and hear in Paris... The work I'm doing here will at least have the merit of resembling no one else's because it will simply be the expression of what I myself have felt, myself alone. The farther I go, the more I regret the little I know, for it is precisely that which most handicaps me." Except for Manet and Degas, who had gone through the schools and studied painting in the orderly classical manner, neither Monet nor the others remained long in the Paris studios. Renoir and Cézanne were assiduous visitors to the Louvre, but were guided entirely by their instincts. The group's decisive contacts with their elders—Jongkind, Boudin, Courbet, Corot, Diaz, Daubigny—had all been made at random while working directly from nature, either on the Channel coast or in the Forest of Fontainebleau. And what they garnered from them were not scraps of theory, but a living example.

During their stays in Paris, however, these artists did not fail to join in the intense artistic and literary life of the day, still agreeably imbued with easy-going Bohemian traditions. Among the liveliest meeting-places were the studios of Manet and Fantin-Latour; the studio of Bazille, who warmly welcomed Monet and Renoir there when, as frequently happened, neither had a place to stay; the open house held by Commandant Lejosne, Bazille's cousin and Manet's sponsor; last but not least, the cafés, whose non-committal character best lent itself to the free exchange of ideas.

After 1866 Manet stopped going either to Tortoni's or to the fashionable Café de Bade on the Boulevard des Italiens and chose a new headquarters nearer his studio in the new Batignolles district. This was the famous Café Guerbois, which played the same part in crystallizing his aesthetic as the old Brasserie des Martyrs did for Courbet. The heyday of the Café Guerbois gatherings ran from 1868 to 1870, when Manet could be seen there in the evenings joking, chatting, arguing with such men as Zola, Astruc, Duranty, Duret, Guillemet, Bracquemond, Bazille, Degas, Fantin, Renoir, Edmond Maître, the photographer Nadar and, when they were in town, Cézanne, Sisley, Monet and Pissarro.

Unfortunately, with but the meagerest accounts of what actually went on there to enlighten us, we can only speculate on the real atmosphere of the place, the fruitfulness of the ties that formed between writers, artists and dilettantes, the nature and scope of discussions that no doubt often lasted far into the night. Much of interest and significance must have been said, however, if we judge by the regular attendance of Cézanne, usually so mistrustful of such talk, and of Monet himself, so hostile to theory, who later admitted that the discussions at the Café Guerbois had gone far towards clearing up many points of his own aesthetic.

Cultivated Parisians both, brilliant talkers, witty, caustic and adroit in argument, Manet and Degas took the lead at these gatherings. Two writers seconded them: Edmond Duranty (1833-1889), the former theorist of realism, an intimate friend of Degas, a warm advocate of the "New Painting," and Emile Zola (1840-1902), who first made his name in 1866 with an outspoken series of articles in favor of Manet, and who, in his review of the 1868 Salon, clairvoyantly singled out Monet and Pissarro for high praise. Stress should be laid on the very high standards of art criticism prior to 1870, for which the impact of Baudelaire was largely responsible, though an important factor too was the close and fruitful contact that then prevailed between the younger critics and artists. Though later he foolishly repudiated these youthful enthusiasms, Zola had had the good sense to throw off the heavy cloak of doctrinarian realism and to appreciate the subjective creative personality for what it was. "The word realist," he wrote in 1866, "means nothing to me, for I put temperament higher than truthfulness. Paint what is true and I applaud. But paint what is most alive and individual in you and I applaud even more." Thoré-Bürger (1866 and 1868 Salons) and Zacharie Astruc (1868 Salon) admired the pictures sent in by Manet, Degas, Renoir, Monet, Pissarro and Bazille and wrote accordingly. Castagnary, the official champion of realism, followed the Salons each year from 1857 to 1879; in 1863 he noted the decisive swing in another direction and wrote in 1868 that "a revolution, radical both in form and content, is taking place." Théodore Duret (1838-1927), reviewing the 1870 Salon, analyzed the situation on the eve of the Franco-Prussian War. He staked out the limits of naturalism in painting and concluded in favor of the new aesthetic, that of the artist "who, having his own way of viewing things, succeeds in recording this vision on canvas in an appropriate form that at the same time puts across his impression."

At his studio at 9, Rue de la Condamine, in the Batignolles district near the Café Guerbois, Bazille kept open house to his friends, his hospitality being especially appreciated by Monet and Renoir, who were often hard put for a place to live and work in Paris. This picture is a testimony to the comradeship of those early days. Easily identifiable are Edmond Maître, seated at the piano, Zola leaning over the banister of the stairway, Renoir lounging on the edge of the table, Manet wearing a hat and, behind him, stroking his beard, Monet, inspecting the canvas that Bazille, palette in hand, is showing them. Bazille's own figure was painted in by Manet.

FRÉDÉRIC BAZILLE (1841-1870). THE ARTIST'S STUDIO, 1870.
(38×50″) LOUVRE, PARIS.

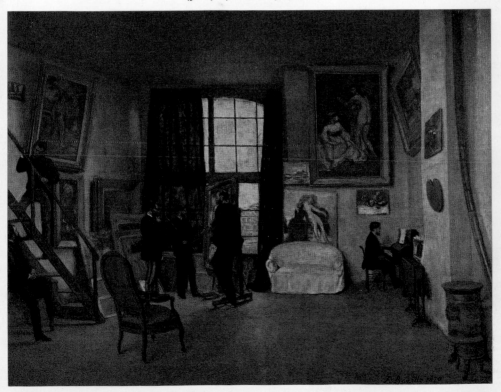

CLAUDE MONET (1840-1926). VIEW OF WESTMINSTER BRIDGE AND THE
HOUSES OF PARLIAMENT, 1871. (18¾ × 29¾″)
COLLECTION OF THE HON. JOHN ASTOR, LONDON.

In September 1870, with the German armies pouring into northern France,
Monet took ship for England from Le Havre, where he had been painting
all summer. In London he rejoined Daubigny and Pissarro, and made the
acquaintance of the dealer Durand-Ruel. The following year, with the war
over, he made his way back to France via Holland, reaching Paris again
early in 1872. During this first stay in London he painted chiefly landscapes
in Hyde Park and a few views of the Thames, of which the finest is this one,
showing Westminster Bridge and the Houses of Parliament. Monet visited
England again in December 1891, then went back three or four times
between the autumn of 1899 and the winter of 1904 so as to carry out
his series on the Thames: 37 canvases in all, exhibited at Durand-Ruel's
in 1904. Only in these late works did Monet's vision at last hark back to
Turner. The above canvas, however, remains strictly classical in structure.

INTERLUDE IN ENGLAND

ON the 18th of July 1870 the outbreak of war put an end to painting and scattered the group far and wide. A lieutenant in the National Guard, Manet served directly under Meissonier, who was a colonel. Degas was called up for service in an artillery unit, where his friend Henri Rouart soon joined him. Assigned to a light cavalry regiment, Renoir was stationed at Bordeaux, where he painted a portrait of Captain Darras, his commander. Having volunteered for the Zouaves, a *corps d'élite* sent straightaway to the front lines, Bazille was killed in the fighting at Beaune-la-Rolande on November 28. Cézanne left the call to arms unheeded and retired to L'Estaque, near Marseilles. After a brief stay with his friend the painter Piette at Montfoucault (Mayenne), Pissarro made for London, where his mother lived. From Le Havre, where he was hard at work painting, Monet, too, took ship for England, in September.

After having been so close and fruitful between the romantic painters (Géricault, Delacroix, Bonington and the English water-colorists), contacts between artists and writers in England and France again flourished in the second half of the 19th century. Between 1859 and 1865 Whistler, Fantin-Latour and Legros shared their time equally between London and Paris. In July 1868, finding himself at Boulogne, Manet paid a brief visit to England, coming back "delighted" with what he had seen and the cordial welcome extended him. Monet and Pissarro found themselves in a far less favorable position; they knew no one in England and were practically penniless, while their work was as yet utterly unrecognized. But in these straits Monet had the good fortune to run into Daubigny, who had already visited London in 1867 and was now painting views of the Thames that were much sought after. Daubigny had always encouraged Monet and defended his work in the jury debates at the Salon.

In his youth Turner aspired to an ambitious synthesis of all the tendencies underlying the English landscape—Dutch, French and Italian. The vast compositions that came of this, many of them mythological, met with entire success at the Royal Academy, where he was welcomed as a member in 1802, at the age of 27. At the same time he sketched directly from nature in a manner that foreshadowed Constable. Only much later, however, after many trips abroad, and only after seeing Venice, did his remarkable gifts as a visionary colorist finally ripen, as he came to express an almost cosmic suspense through the magic properties of light.

WILLIAM TURNER (1775-1851). RAIN, STEAM AND SPEED, 1843. (35¾×48″) BY COURTESY OF THE TRUSTEES, NATIONAL GALLERY, LONDON.

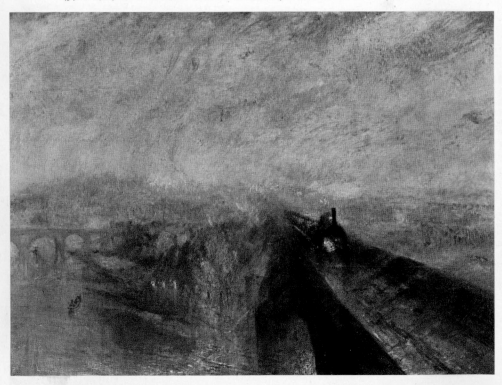

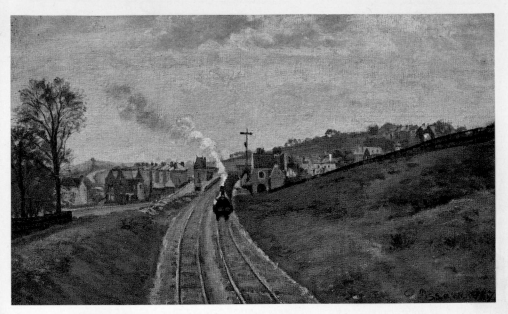

CAMILLE PISSARRO (1830-1903). PENGE STATION, UPPER NORWOOD, 1871. (17½×28½") COURTAULD INSTITUTE, LONDON.

Pissarro sought refuge in London during the Franco-Prussian War and the Paris Commune, from September 1870 to June 1871. Having taken a liking to England, he repeated this visit in the spring of 1890, June 1892, May 1897 and autumn 1899. In 1883 he sent his elder son Lucien to London, writing to him on February 20: "You went to the National Gallery and saw the Turners. You make no mention of them. You must have been struck. What about the famous picture of a train?" The picture he had in mind is obviously *Rain, Steam and Speed*, dating from 1843, easily the first appearance of a locomotive in painting. A modern theme *par excellence*, the railway was taken up by all the Impressionists, the best-known example being Monet's series on the *Gare Saint-Lazare*. Pissarro preceded him by several years with this work, painted in 1871, inspired by Turner as far as the theme goes, but completely different both in spirit and technique. Turner's locomotive bursts out of a rapturous chaos, a phantasmagoria of swirling cloud, fog, steam and water; Pissarro's chugs sedately out of a way-station on a green hillside, its trail of smoke casually streaking an idyllic sky.

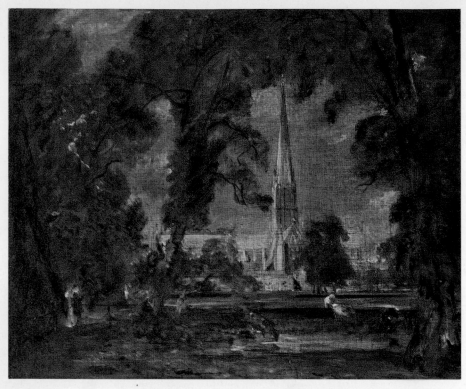

JOHN CONSTABLE (1776-1837). SALISBURY CATHEDRAL, 1823.
(25 ½ × 30″) PRIVATE COLLECTION, LONDON.

This superb "sketch" of *Salisbury Cathedral seen from the Bishop's Garden*
dates from 1823, by common consent Constable's best period. "One of
the finest performances in the history of painting," is Lionello Venturi's
comment on this picture. "Out of a harmony of browns and blues rises a
light of sheer imagination. For all their luminosity, the trees are made of
dark touches so as to confer the strongest shaft of light on the steeple.
Round that light the branches seem to sway loosely to and fro with
incomparable grace. Not until Cézanne do we again reach heights like this."

Here is the most obvious example of Constable's influence—a like theme, a like sweep of vibrant light round the bell-tower, amid outstretched branches. The old delight in broken gleams on rippling water, consistently indulged in before 1870, again forms the unifying principle of the picture, but the brushwork and style have greatly gained in vigor and freedom since pre-war days. The grey-brown harmonies handed down by Corot ascend to a pitch of richly mingled pinks and yellows, though Pissarro keeps a level-headed grasp on his imagination and deepens his insight into nature.

CAMILLE PISSARRO (1830-1903). DULWICH COLLEGE, 1871. (19½×24″)
JOHN A. MACAULAY COLLECTION, WINNIPEG.

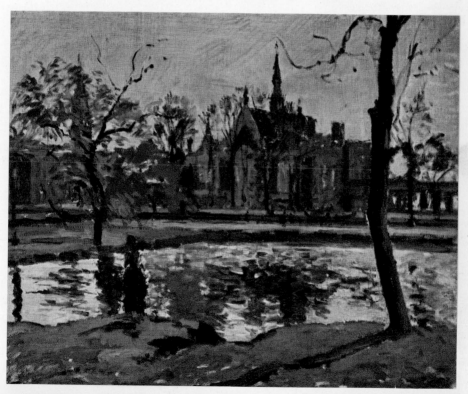

Now he cordially introduced him to his dealer, also a refugee in London: Paul Durand-Ruel, who had just opened a gallery at 168 New Bond Street, where from 1870 to 1875 he organized ten consecutive exhibitions of modern painting. The name of Durand-Ruel is inseparably linked with the Impressionists' struggle for recognition, a twenty-years' struggle in which he courageously, selflessly took part. Pissarro dropped into the new gallery with a picture under his arm, submitted it to Durand-Ruel who bought it outright, and through him learnt to his surprise that Monet too was in London. Reunited, the two comrades set to work together, and now, in London in 1871, there arose between them much the same friendly rivalry that had spurred on Monet and Renoir at Bougival in 1869. Sisley, too, must have been in London at the time as his painting of *Charing Cross Bridge* is dated 1871; but nothing is known of his stay there, nor have we any evidence to show that he was in touch with Monet or Pissarro. Even the latter's stay in London has been much embroidered on by art historians. Actually, only one reliable firsthand account of it has come down to us: the letter written by Pissarro himself in 1902 to the English painter Wynford Dewhurst, who was preparing a book on Impressionism and approached him for material. "In 1870," wrote Pissarro, "I was in London with Monet, where we met Daubigny and Bonvin. Monet and I were thrilled by the landscapes in London. Monet worked in the parks; as for me, since I lived in Lower Norwood, at that time a charming suburb, I made studies of fog effects, of snow and springtime. We worked directly from nature, and later on Monet painted several superb studies of fog in London. We also visited the museums. The paintings and watercolors of Turner and Constable, as well as canvases by Old Crome, certainly influenced us to some extent. We admired Gainsborough, Lawrence, Reynolds and others, but were mort impressed by the English landscape-painters..."

Monet made two trips to Holland whose exact dates, however, have not been recorded. He went for the first time in 1871 on his way back to France from London, at the suggestion of Daubigny, who may have accompanied him, since he, too, is known to have been in Holland in 1871-1872. Monet's second trip, following hard upon the first, was made some time in 1872. Located only a few miles to the northwest of Amsterdam, Zaandam is a picturesque village full of gardens and criss-crossing canals lined with quaint cottages painted in a wide variety of colors, in which, beneath the red-tiled roofs, green seems to dominate, to judge by Monet's picture of the place. He made several views of Zaandam, one of which was bought by Daubigny. This charming work betrays not the slightest influence of the paintings by Turner that Monet had just seen in London, though there is something in it of the fresh, crystalline limpidity of Japanese prints.

CLAUDE MONET (1840-1926). VIEW OF ZAANDAM, 1871. (18 × 28 ¼″)
LOUVRE, PARIS.

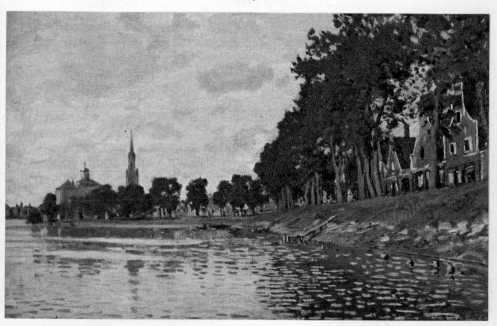

But realizing that Dewhurst was prone to over-estimate the role of his own country in the rise of Impressionism, Pissarro followed up with a second letter, no less important, in which he restored the balance and linked Impressionism to the French tradition, its true and natural background: "I do not feel, as you do, that the Impressionists were closely in touch with the English school, and this for various reasons too lengthy to go into here. It is true that we owed something to Turner and Constable... but the roots of our art lie unquestionably in the French tradition. Our masters are Clouet, Poussin, Claude Lorrain, the 18th century with Chardin and the 1830 group with Corot."

A revival of 18th-century ideals had been launched by the Goncourts between 1862 and 1869. Though baneful in its effect on official tastes, which clung to its anecdotal side and its battery of artifices, it met with a warm response from the Impressionists, who grasped the true message of the 18th century. Renoir is far and away the noblest heir of Fragonard and Boucher, Manet learnt much from Chardin, and all of them reveled in the freshness and incomparable technical perfection of this painting, as gracefully attuned to the life and poetry of its time as theirs with their time.

As for the imputed influence of the English school, we need only compare Monet's and Pissarro's work before and after their stay in London to convince ourselves that no true stylistic change occurred in the interval. Naturally enough, they took at once to the evanescent light of London, to the endless variety of fog and smoke effects. But these they coolly analyzed with their accustomed accuracy, without losing their heads over them, and the works of this period, which may be taken as the end-point of their "naturalistic" phase, stand in staunch opposition to the romantic and sentimental traditions of English landscape. For English painters nature had been a source of delicious reverie, of aspiring emotions always tinged with romanticism

or grave moral injunctions. For the French Impressionists it was an object of visual sensations as pure and well-differentiated as could be. In his theoretical treatise, *D'Eugène Delacroix au Néo-impressionnisme*, Signac adduces the influence of Turner as follows: "In 1871, in the course of a long stay in London, Claude Monet and Camille Pissarro discovered Turner. They marveled at the wizardry of his colors; they studied his works, analyzed his technique. They were struck at first by his snow and ice effects. They were amazed at the way he succeeded in conveying the sensation of snow's whiteness, they themselves having hitherto failed to do so with their large patches of silver white spread on flat... Then they saw that these wonderful effects had been got not with white alone, but with a host of multicolored strokes, dabbed in one against the other, and producing the desired effect when seen from a distance."

Even granting this much, however, the fact remains that Turner's intuitive use of this technique differed fundamentally, both in spirit and actual practice, from the very direct, very precise approach of the French Impressionists, typified in the snowscapes reproduced here. Things are again shown in their right light by Pissarro himself in a letter to his son Lucien in 1902, which, although written to quash Dewhurst's unreasonable claims, almost reads like a rejoinder to Signac: "Though helpful in many ways, Turner and Constable, we soon realized, never understood the analysis of shadows, which, with Turner, are always a kind of preconceived effect, a mere hole in the canvas. As for the division of tones, Turner showed us its value as a procedure, but never its true accuracy or its real nature."

Pissarro, however, generously acknowledged the debt to Turner and Constable, who, whatever their shortcomings, came as a revelation to the Impressionists, whose evolution they certainly hastened, despite the fact that their most freely drawn sketches—like those of Corot—were then unknown. During

later stays in London (Pissarro and Sisley also made subsequent trips to London) and particularly in his final works, Monet came very close to the cosmic vision peculiar to Turner, whose rather theatrical exuberance had chilled him at first. Pissarro readily responded to the earthy side of Constable, whose artistic integrity and fine awe of nature much appealed to him. Midway between the staid and meticulous realism of his youth and the out-and-out romanticism of his last works, Constable seemed to strike a period of emotional equilibrium and visual spontaneity, running from about 1820 to 1825, which foreshadowed and even matched the pre-impressionist style of Corot on his first trip to Italy. It was then that he dropped all idea of "grandeur" for a "smaller realm." He no longer strove for vast panoramic effects, but cultivated motifs of homely simplicity, more closely wedded to nature as a whole by variations in light.

Durand-Ruel began to hang Monet's and Pissarro's works alongside those of the Romantics and the Barbizon School in his gallery. The two young men made a concerted attempt to get a showing at the Royal Academy, but nothing came of it. En route for the United States on the first leg of a round-the-world journey, Duret stopped in London, where he paused to admire Pissarro's latest canvases. By the end of June 1871 Pissarro had gone back to Louveciennes only to find his studio ransacked by German troops; a large part of his pre-1870 output was thus destroyed or stolen. Acting on the advice of Daubigny, who may have accompanied him, Monet returned to France by way of Holland, which he visited again in 1872, delighted with the quaintness of the country, its waterways and ships, the windmills outlined against the immensity of the sky and motionless cloud-rack, the gay colors that enliven the grey light. Here the wonderful limpidity of Japanese prints was brought home to him more vividly than in Paris, while for the first time he took the full measure of Jongkind's and Van Goyen's genius.

THE IMPRESSIONISTS IN 1872

IN FEBRUARY 1871 Manet visited his family in the Pyrenees, at Oloron-Sainte-Marie, where they had taken refuge, then made his way northwards again in easy stages along the Atlantic coast, painting a number of fine, vibrant seascapes, of which perhaps the finest is *Bordeaux Harbor*, a forest of masts and sails streaking the pale blue of the sky. He reached Paris in the last bitter days of the Commune, then spent the summer at Boulogne, making excursions to Calais. In January 1872 Durand-Ruel suddenly bought up all the canvases in his studio, some thirty pictures, for which he paid outright the unheard-of price of fifty-one thousand francs. To celebrate this windfall, Manet threw a brilliant reception in July at his new studio at 4, Rue de Saint-Petersbourg. In August he traveled to Holland to make a firsthand study of Frans Hals.

Shortly before the war, in 1869, Durand-Ruel had moved his gallery from the Rue de la Paix to the Rue Laffitte, and in the *Revue Internationale de l'Art et de la Curiosité*, a journal of his own intended to encourage younger artists, he thus defined his program: "A picture-dealer worthy of the name must at the same time be an enlightened art-lover, prepared on occasion to sacrifice his immediate interests to his artistic convictions and resolved to contend against speculators rather than lend himself to their game." Upon his return from London he renewed his contacts with Monet and Pissarro and showed a keen interest in Degas and Sisley. By 1872 he had arranged an initial exhibition that included seven Monets and three Pissarros, then a second with six Manets, two Degas, two Monets, four Pissarros and four Sisleys. In January 1873 he issued a complete catalogue of his gallery with a preface by Armand Silvestre that traced the new painting back to Delacroix and Courbet and foretold its ultimate success on account of its "singularly cheerful range

of colors." In the same article the personality of each land-scapist is aptly summed up in a few words: "Monet is the most skillful and venturesome, Sisley the most harmonious and timid, Pissarro the most realistic-minded and naïve."

By 1872 Degas had begun to attend dance rehearsals at the old Paris Opera in the Rue Le Pelctier, painting almost imme-diately the small jewel-like canvas in the Louvre, with its blend of yellow-greys and delicate blues, and the unusual note struck by the empty chair on the empty stretch of floor in the fore-ground. At the end of October he set sail for New Orleans with his brother René. After returning to Paris the following spring, he devoted his magnificent technique to painting the most accurate picture we have of 19th-century life.

With the war over, Renoir spent two leisurely months as the guest of friends in a château in the south of France, riding daily on horseback and giving painting lessons to the daughter of the family. Virtually penniless, but smiling at life as long as he was free to paint, he returned to Paris and divided his time between his lodgings in the Rue du Dragon and his mother's home at Louveciennes. He painted his *Portrait of Madame Maître*, wife of the musician he had met at Bazille's, who initiated them all into the music of Wagner and Berlioz. Then came his *Portrait of the Henriot Family* idly enjoying a summer's day on the banks of the Seine, followed by *Parisian Women dressed as Algerians*, his last pastiche, which resoundingly freed him from the influence of Delacroix, Diaz and Courbet, now fully assimilated at last. In 1872 he dashed off a set of blithe and sparkling views of Paris —*Quai Malaquais* and above all *Le Pont-Neuf*—, in which the delightful spontaneity of his style wells up in a blue and yellow harmony replete with sunny optimism. In 1873, having been welcomed into the fold by Durand-Ruel, he was able to take a vast studio in Montmartre at 35, Rue Saint-Georges, and laughingly declared that he had now "arrived."

This is one of the first canvases Pissarro painted after settling at Pontoise in 1872. Canal-boats and lighters are moored along the bend in the river, seen as the Oise winds away amid trees and hillocks, a motif permitting of great freedom and variety in the organization of space and volumes. On the left bank stand scattered dwelling-houses and a factory puffing smoke into the sky. In the mid-picture foreground floats the wash-house, with a group of women scrubbing away. Another idles on the path above and, sidling behind a tree, seems to be watching the painter at work.

CAMILLE PISSARRO (1830-1903). THE WASH-HOUSE, 1872. (18×21½″)
LOUVRE, PARIS.

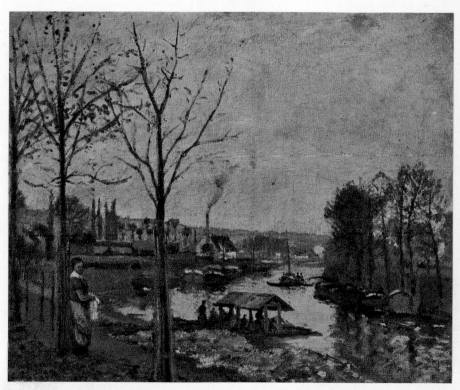

Monet got back to Paris from Holland late in December 1871. The first visit he paid, loyally accompanied by Boudin and Armand Gautier, was to Courbet, who, having taken a leading part in the Commune uprising and accused of being the ring-leader in the dismantling of the Colonne Vendôme, was now languishing in prison at Sainte-Pélagie, where he whiled away

ALFRED SISLEY (1839-1899). THE CANAL, 1872. (15×18″)
LOUVRE, PARIS.

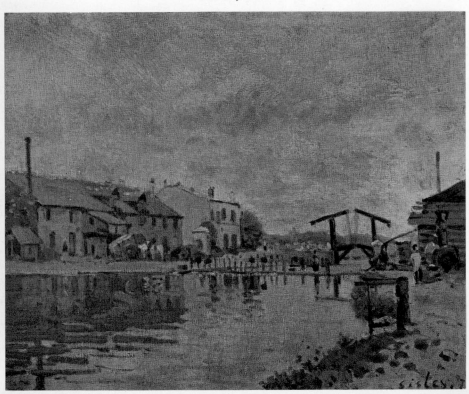

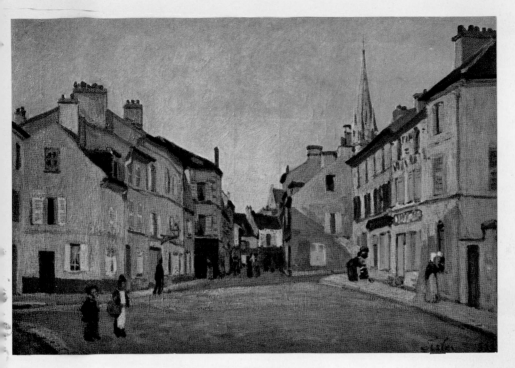

ALFRED SISLEY (1839-1899). THE SQUARE AT ARGENTEUIL, 1872.
(18×25 ½″) LOUVRE, PARIS.

the time by painting some admirable still lifes of flowers and
fruit. Back from his second trip to Holland in 1872, Monet
settled down—and stayed there until 1878—at Argenteuil, a
village on the banks of the Seine, where he established the
headquarters of Impressionism. There he was soon joined by
Renoir, Sisley, the amateur painter Caillebotte, even by Manet,
who succumbed for a time to his influence. Monet lost his interest
in figure-painting now and concentrated on landscape.

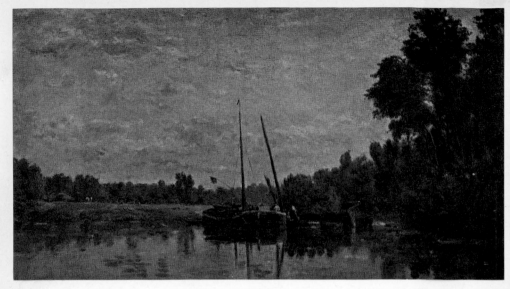

FRANÇOIS DAUBIGNY (1817-1878). THE BARGES, 1865. (15×26½")
LOUVRE, PARIS.

The link between the Barbizon group and the impressionist movement,
Daubigny smoothed out the transition from one to the other. He showed
at the Salon from 1838 on and in 1852 became friendly with Corot. To him
goes the credit for being the first landscapist to paint entirely out-of-doors.
So novel was this at the time that Théophile Gautier dismissed his pictures
as mere "working sketches." When in 1865 he worked at Trouville with
Courbet, Boudin and Monet, one critic singled him out as "the leader of
the school of impressions." As a jury member at the Salon, he regularly
stuck up for the works submitted by the younger artists, particularly those
of Monet. Daubigny set up his easel freely wherever he chanced to be,
in England, Holland, the Normandy coast. In 1857 he fitted up a studio
on his house-boat, "Le Botin," from which he painted countless land-
and waterscapes all along the Oise, whose lush green banks were his
theme of predilection. Monet later saw fit to adopt the same method
on the Seine at Argenteuil. Daubigny looked upon the world in a fresh
and natural way, recording hourly changes of light. He never deviated
from tonal painting, but his work retains a fine sketch-like spontaneity.

This fresh and charming work by Monet forms part of the well-known May triptych at the Louvre, enclosed in a triple frame with a Pissarro and a Sisley of the same period, i.e. 1873, one of Impressionism's finest years. It obviously invites comparison with the picture by Daubigny on the opposite page, similar in theme and presentation. The telling difference between them lies in the wholly new texture of light and color as used by Monet, who transformed the almost bleak objectivity of the scene into a sunny glimpse of a summer's day. These two waterscapes strikingly illustrate the transition from Naturalism to Impressionism, in which light, the actual light of day, became the vital principle of the creative imagination.

CLAUDE MONET (1840-1926). PLEASURE BOATS, CA. 1873. (18½ × 25½″)
LOUVRE, PARIS.

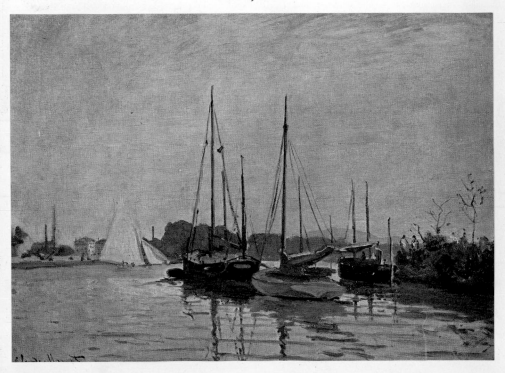

This is the famous canvas painted at Le Havre in 1872, which, when shown at the first group exhibition of the independent painters held in the studios of the photographer Nadar in 1874, unleashed a wave of banter and mockery in which the name "Impressionism" was derisively coined. The orange disk of the sun looms up luridly in the early morning mist and speckles the water in front of two fishing boats. Water and sky merge into an atmospheric "impression" recorded by an acute and sensitive eye with all the truthfulness of a snapshot and all the poetry of a true Impressionist.

CLAUDE MONET (1840-1926). IMPRESSION, SUNRISE, 1872. (19½×25½″)
MUSÉE MARMOTTAN, PARIS.

Faithful to landscape as always, Pissarro left Louveciennes in April 1872 for Pontoise, familiar to him from his stay there prior to 1870; here he lived until 1884. "During the year 1872," writes Lionello Venturi, "he developed his powers in sketching, perfected his tonal values, continually reduced the limits of his motif, which he finally confined to a farmhouse and a couple of familiar trees." The themes most congenial to him were a bend in the river—e.g. *The Wash-house*—or a road stretching away in perspective, with volumes freely organized in space. Earnestly working at his side were Vignon, Guillaumin and Cézanne. In the spring of 1872 the latter settled at nearby Saint-Ouen-l'Aumône and under Pissarro's influence abandoned his dark style for a brighter palette, and his fierce sensual obsessions for the objective study of nature. Thus, with the Impressionists about to hit their stride, we again distinguish the two original groups that had taken form a decade earlier at Gleyre's studio and the Académie Suisse.

This was the brief period of perfect balance, perfect poise between technical means, the demands of the motif, and the painter's personal feelings. With it came the consummate expression of their vision of nature, while the flashing vitality of light effects soon to flare up was still held in check by the delicate, refined, low-pitched colors Corot had always used. No one better expressed this state of things than Sisley, whose work done in 1872 is unsurpassed in the whole of his output. The Moreau-Nélaton Collection at the Louvre, so rich in masterpieces by Delacroix and Corot, stops significantly enough at 1873 as far as impressionist works are concerned, i.e. at the very moment when Impressionism mastered a fully worked-out technique. Perhaps the finest specimens it can show of this peak period are four canvases by Sisley, two of which we reproduce here, *The Canal* and *The Square at Argenteuil*, marvels of grace and accuracy, naïve and tender songs of infinite discretion and purity.

INDEX OF NAMES

LIST OF COLORPLATES

CONTENTS

INDEX OF NAMES

THE COLORPLATES

CONTENTS

THIS VOLUME, THE ELEVENTH OF THE COLLECTION "THE TASTE OF OUR TIME" WAS PRODUCED BY THE TECHNICAL STAFF OF EDITIONS D'ART ALBERT SKIRA, FINISHED THE FIFTEENTH DAY OF JANUARY NINETEEN HUNDRED AND FIFTY-NINE.

TEXT AND ILLUSTRATIONS BY THE

COLOR STUDIO

AT IMPRIMERIES RÉUNIES S.A., LAUSANNE

PLATES ENGRAVED BY GUEZELLE ET RENOUARD, PARIS.

PHOTOGRAPHS

Louis Laniepce, Paris (pages 18, 21, 29, 47, 54, 55, 67, 72, 75, 78, 91, 92, 95, 101, 102, 103, 104, 105, 106): Henry B. Beville, Washington (pages 22, 26, 51, 57, 61, 63, 65, 67): Brigdens of Winnipeg, Canada (page 93): Cliché, Oslo (page 37). Other photographs were obligingly lent by the magazine Du, *Zurich (pages 3, 24, 34, 35, 42, 46, 60), by the Istituto d'Arti grafiche, Bergamo (pages 64, 88), and by the Art Institute of Chicago (Richard G. Brittain, photographer, pages 33, 79).*

PRINTED IN SWITZERLAND

13204